PRACTICAL
printmaking

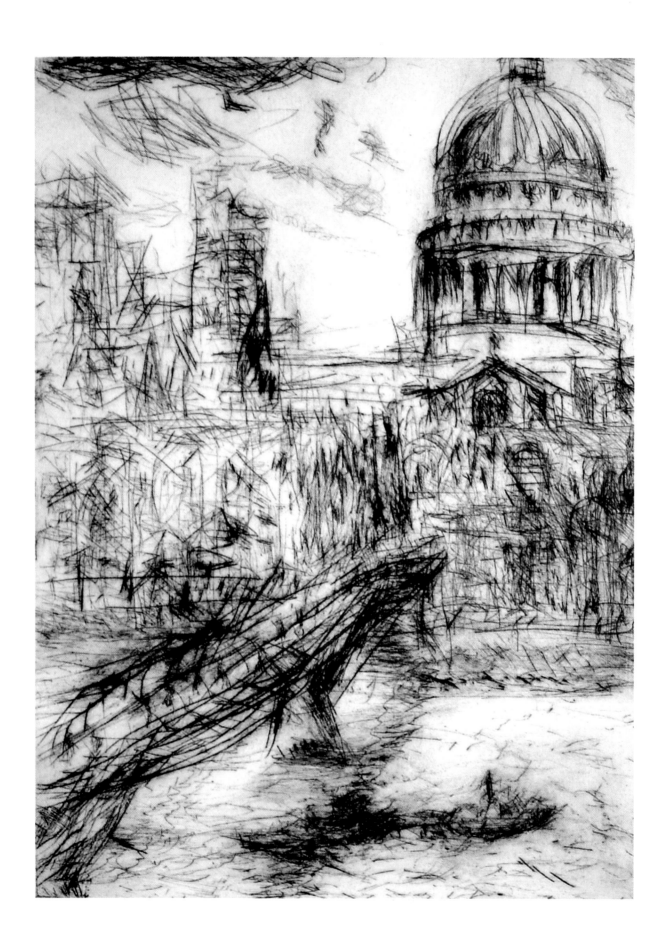

PRACTICAL
printmaking

COLIN GALE

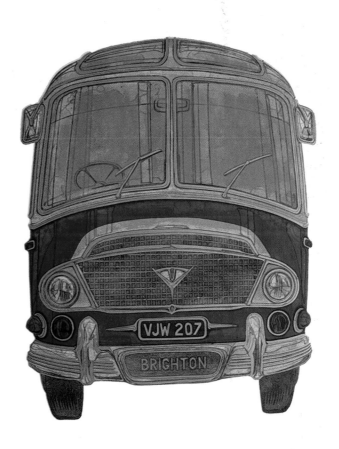

A & C BLACK • LONDON

First published in Great Britain in 2009
A&C Black Publishers Limited
38 Soho Square
London W1D 3HB
www.acblack.com

ISBN-13: 978-07136-8809-2

Typeset in 11 on 14.5pt Celeste

Book design by Susan McIntyre
Cover design by Sutchinda Rangsi Thompson
Commissioning editor: Susan James
Copyeditor: Julian Beecroft

Printed and bound in China

A&C Black uses paper produced with elemental chlorine-free pulp, harvested from managed sustainable forests.

Publisher's note: Printmaking can sometimes involve the use of dangerous substances and sharp tools. Always follow the manufacturer's instructions and store chemicals and inks (clearly labelled) out of the reach of children. All information herein is believed to be accurate; however, neither the author nor the publisher can accept any legal liability for errors or omissions.

FRONTISPIECE *View from Tate Modern*, Rachel Lindsey-Clark, 2006. Drypoint on zinc, 14 x 18 cm (5½ x 7 in.).

Contents

Acknowledgements

I am grateful to the printmakers who allowed their work to be reproduced in this book.

Particular thanks go to Megan Fishpool for her help with the photography and proof-reading. Finally, I would also like to thank Scarlett Massell of Pellafort Press for allowing me access to her excellent screenprinting studio.

Cityscape

Paul Catherall, 2008.

Introduction

"Curiouser and curiouser!" cried Alice
(she was so much surprised ...).

OPENING THE DOOR TO A PRINT STUDIO is to step into a fascinating world of machines, tools and peculiar smells, all of which leads you to exclaim, 'How curious!'

In an instant the onlooker is subject to a world of traditions and skills handed down by generations of artists and craftsmen. Long-established knowledge and ways of making reside comfortably alongside cutting-edge technologies.

As an artist, and as director of Artichoke Print Studio for over 15 years now, I have always enjoyed the look on people's faces when they visit the studio for the first time. As they step through the studio door they find a visual collision of the old and the new side by side – the 18th century side by side with the 21st. This is one of the things that I believe makes print-making such a wonderful creative tool. It has a history to base itself on. Everything you might choose to make a print with is still relevant today, no matter how far back it comes from in printmaking history.

As the title of this book suggests, it is a practical guide to the fundamentals of printmaking. Written in step-by-step format, *Practical Printmaking* is intended to stick as closely as possible to the way that I teach the subject, with discussion and practical demonstrations.

Printmaking is so approachable that it is suitable for any level of artistic ability. Children take to it naturally, as do adults, whether non-professionally or professionally, as hobbyists, collectors or patrons. Artistic practice can often be isolating; printmaking is a naturally communal activity where equipment, tools and ideas are shared. Creative sparks fly and the energy is contagious.

The intention of this book is to perpetuate all of the above. A practical manual which introduces printmaking techniques, it is meant to be used with the A&C Black titles in the Printmaking Handbook series, each of which in their own way provide the artist with a wonderful choice of print-making topics to explore, experiment with or discover!

Enjoy your printmaking.

1 Equipment, Tools, Materials

INTAGLIO PRESSES

AS IT IS ONLY RELIEF PRINTS that can be successfully hand-printed, the use of a printing press is paramount for most printmakers. A printing press is the most expensive single item in a printmaking studio. However, once purchased a good press should last a lifetime.

Presses are available in varying sizes with bed widths ranging from 15 cm (6 in.) to 2 m (6 ft 6 in.) for a custom-made model. Prices for a new press roughly correspond to the press size, and can be anything from a few hundred to many thousands of pounds. Budget aside, there are factors to be weighed up before you consider buying a press. For instance, where is it to be used – in a shared studio or a home studio? There are space and weight issues to be considered here. Also, what type of work is it needed for – multiple techniques or specifically for one process? Is the press for professional work, for school use or for use as a hobby?

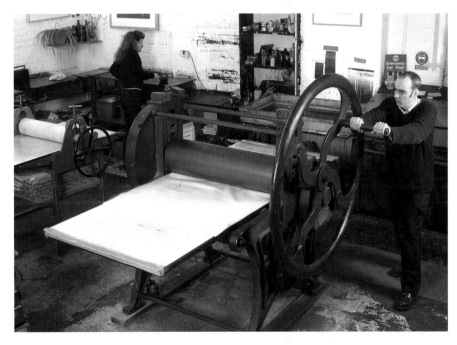

ABOVE **Artichoke Print Workshop, London.**

LEFT **Heavy-roller presses at Artichoke Print Workshop, by John Haddon and Harry Rochat. This type of press is very popular with etchers. The design is based on Victorian models. They are very heavy and require installation by professional machine removers. In a home studio they should be located on a solid ground floor. These presses deliver the best printing quality for intaglio techniques due to the weight of the rollers. They are substantially built and so make an excellent choice for shared studios where there will be heavy usage.**

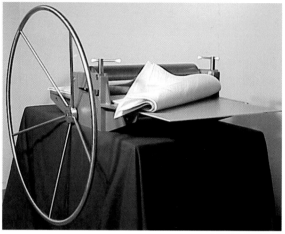

A star-wheel press at Intaglio Printmaker in London. This is a bench-top model with direct drive (no gearing). A simple design sold in different widths, it is very practical for home or school use, as it can be positioned on any sturdy tabletop. This type of press represents very good value for money.

An American KB press. Available as a tabletop model or freestanding with a pedestal, this press has a gauge-marked counter-fulcrum pressure system, which allows the top roller to be adjusted up and down. This makes the press extremely versatile, as it will print blocks of varying thickness as well as plates.

My recommendations when considering a press are:

- Look for a solid construction/build.

- Go for the largest-diameter rollers. These will produce the best prints. A standard sheet of printmaking paper is the old Imperial measurement of 22 x 30 in. (56 x 76 cm). A bed size that accommodates this size of sheet is a definite advantage.

- Try out the press and talk to someone who already owns one.

RELIEF PRESSES

Traditional relief presses such as the Albion and Columbian press were perfected over hundreds of years to do the job of printing text and illustrated blocks. These presses print with downward pressure and are the best option for all types of relief prints. However, due to their antique nature they are much sought-after and very expensive. Intaglio presses with top-sprung rollers can be successfully used for relief printing, as can nipping or bookbinding presses.

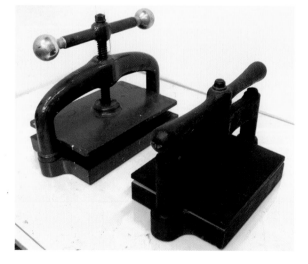

Nipping/bookbinding presses. These can often be purchased at antiques fairs, and it is also worth checking online auctions such as eBay.

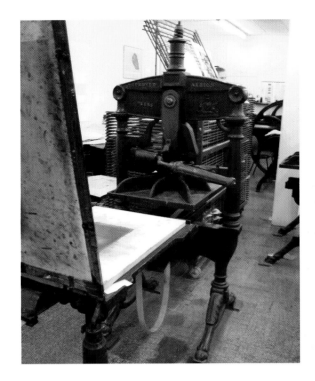

An Albion press.

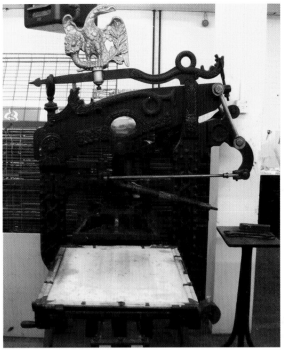

A Columbian press at Maidstone College of Art.

LITHOGRAPHIC PRESSES

Lithographic presses for printing stones are no longer made, so need to be purchased second-hand. Lithographic plates can also be printed using an etching press, as shown on page 90.

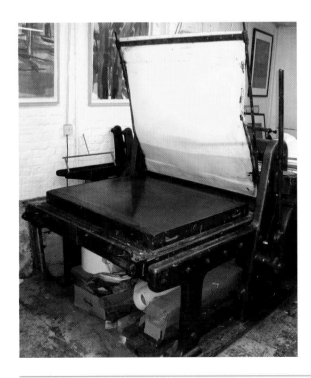

ABOVE **A stone lithographic press at Oxford Printmakers.**

LEFT **A large motorised lithographic press for plates at Artichoke in London.**

SCREENPRINTING

Basic screenprinting can be achieved using a wooden screen that is hinged to a sturdy wooden baseboard. This is a very successful way to print small- and medium-scale work. The screen and baseboard can then be stored away when not in use, freeing up workspace.

For medium- to large-scale screen work, a screen table is needed. The screen is securely clamped in a frame, which is counterbalanced at the rear. The tabletop has hundreds of holes in it, and these are connected to a vacuum pump, ensuring that the paper stays securely in position during printing. The printing squeegee is held in an arm/lever that travels horizontally. This holds the squeegee at the correct angle as well as making printing effortless.

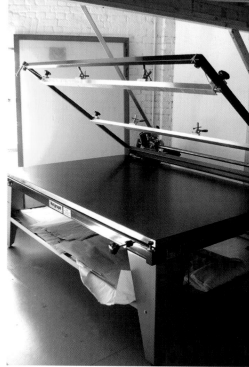

ABOVE **A Natgraph screen table in Scarlett Masell's studio in Brixton, London**

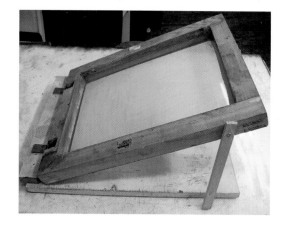

RIGHT **A wooden screen hinged to a plywood base. Note the strip of wood screwed to the frame side, acting as a leg with which to stand the screen in an upright position.**

GENERAL EQUIPMENT

ROLLERS

An assortment of rollers is needed for inking plates and blocks, and rolling on grounds.

I prefer to have a few good-quality rollers rather than many cheap rollers. The best rollers are larger in diameter and therefore have superior rolling capacity. If looked after and cleaned properly, a good roller will

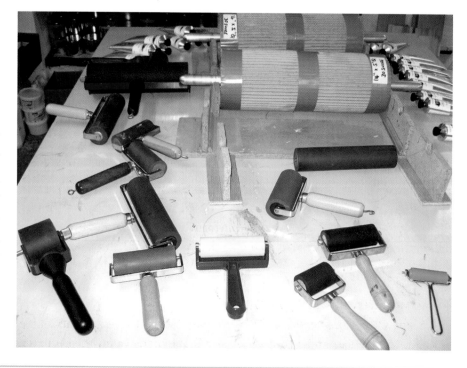

A range of rollers to suit all budgets, courtesy of Intaglio Printmaker in London.

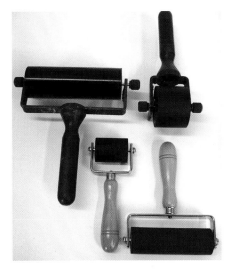

LEFT Two 'economy' rubber rollers and two 'quality' polypropylene rollers (approximately four times the cost of the cheap ones).

PALETTE KNIVES

Used for mixing and spreading inks, palette knives can be surprisingly expensive if purchased from printmaking suppliers.

ABOVE Decorator's knives are a practical option. This set of three was purchased from a pound shop.

ABOVE A simple knife storage rack can be easily constructed from scrap timber. Note also the cut-down plastic carton for storing card-inking strips.

SOLVENT DISPENSERS

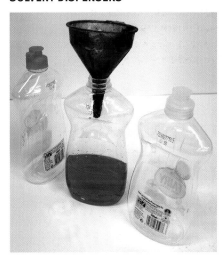

Save money and recycle by using empty plastic washing-up-liquid bottles for holding cleaning solvents such as methylated and white spirits. make sure they are clearly labelled.

TOOLS

Tools can be an expensive purchase. Most printmakers build up a collection of tools over many years of practice. Some tools, such as an etching needle and a drypoint tool, perform very basic functions, so it is not necessary to pay a lot of money for them. Overleaf I show you how to make two tools that are perfectly sound to use.

HOW TO MAKE BASIC INTAGLIO TOOLS.

There are numerous tools that can be purchased from a printmaking supplier. The choice can be confusing as well as expensive for the beginner.

It is worth considering that Intaglio points have a very simple function, to scratch through a wax or acrylic ground or in the case of drypoint to scratch into a plate's surface.

An advantage with homemade tools is that you can fashion the tool's point to a particular shape or size. If the tool's point is very sharp it will produce a very different line to a tool that has a blunt rounded tip.

Even an experienced printmaker who in all probability will have already amassed a wide selection of shop bought tools will no doubt have recourse to make homemade tools.

This section shows two options on how to quickly make perfectly usable tools that literally cost pennies.

MAKING AN ETCHING NEEDLE

You will need a cheap wooden handled paintbrush, a gramophone needle, epoxy resin glue, a junior hacksaw and a drill with a fine drill bit.

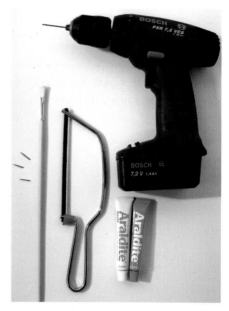

Equipment for making an etching needle.

RIGHT **First cut off the end of the paintbrush using the hack saw to a length of approximately 6 inches [the length of a biro].**

FAR RIGHT **Taking the drill, slowly drill a shallow hole approximately 5 mm deep into the end of the cut off brush. It is important to ensure the hole is drilled parallel to the handle otherwise the point will be crooked when inserted**

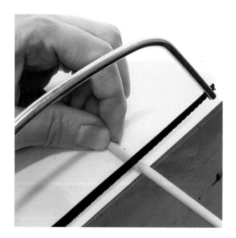

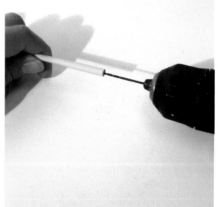

RIGHT **Mix the epoxy resin glue. [This type of glue is a two-part glue that creates an extremely strong bond. Squeeze an equal pea sized amount from each tube and mix together] Place a little of the glue on the flat end of the gramophone needle and insert the needle into the hole.**

FAR RIGHT **Spread glue over the base of the needle where it joins the handle. Ensure the needle is straight and leave to dry for several hours. This tool will be suitable for drawing very fine lines through a wax or acrylic ground. It will not be strong enough for using as a drypoint tool.**

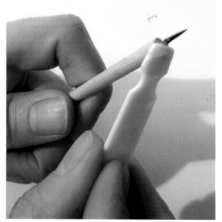

Six-inch nails make excellent etching needles. Generally an etching needle should have a slightly blunt point.
It is possible to create a range of tips by filing the nails to varying widths and points. When used through a ground these tools will create a variety of lines.

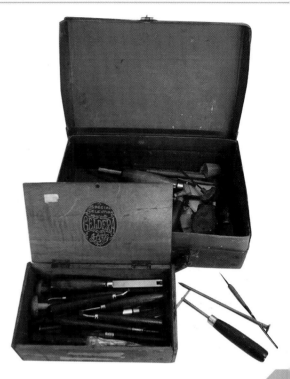

MAKING A DRYPOINT TOOL

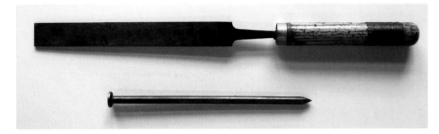

You will need a six-inch nail and a file.

RIGHT **Grip the nail firmly and sharpen using a fine file. Rotate the nail in your hand so that it is filed evenly all round. For use as a drypoint tool the nail should be very sharp.**

BELOW **The filed drypoint tool ready for use.**

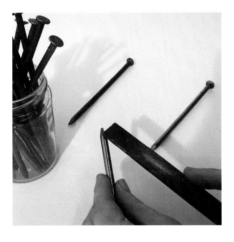

ABOVE **Tools belonging to the author. Note the improvised tools to the right – a 6-inch nail and a dart.**

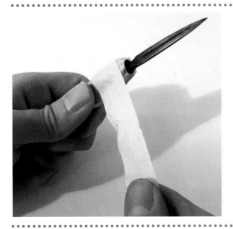

TIP BIND TOOL HANDLES BY WRAPPING THEM WITH MASKING TAPE. THIS PADS THEM OUT MAKING THEM EASIER TO GRIP. THE TOOL SHOWN IS A SCRAPER FOR MAKING CORRECTIONS.

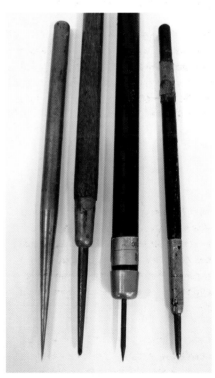

ABOVE **Shop bought intaglio tools**
Left to right – drypoint tool, etching tool blunt tip, etching tool sharp point, antique etching tool.

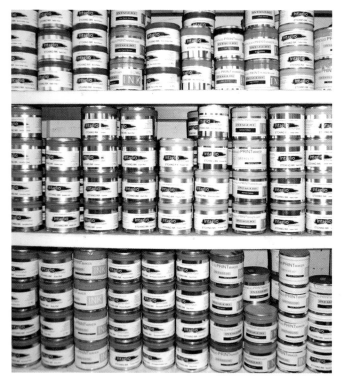

Tins of etching ink at Intaglio Printmaker in London.

BELOW Intaglio ink in tins, caulking gun and tube.

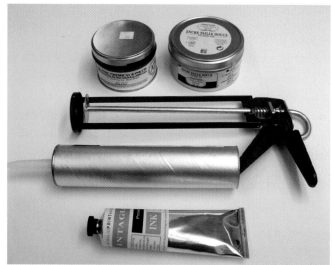

INK

In recent years the choice of inks available for the printmaker has widened. The newest developments include intaglio oil-based inks that are water-washable. Inks are available in tins, tubes and caulking guns. Those stored in tubes or caulking guns have the advantage that they do not skin, as ink tends to do in tins once these have been opened.

It is rare now to find a studio that uses oil-based inks for screenprinting, due to health and safety issues surrounding the solvents used for cleaning. Professional editioning studios still tend to favour oil-based inks, as they prefer the advantages in surface coverage and stencil-making options.

When purchasing inks it is wise to consult a colour chart, as colour names can be unfamiliar compared to those of artists' paints.

INTAGLIO INKS

Inks for intaglio printing have always been oil-based, as this method of printing requires the use of dampened paper. If you wish to cut down on solvent use, new oil-based water-washable inks have been specially formulated for intaglio printing.

Safe Wash etching inks made by Caligo. These are linseed-oil-based and are cleaned up with soap and water.

LITHOGRAPHIC AND RELIEF INKS

Inks for relief printing and lithography are mixed to a stiffer consistency than etching inks. These inks can be used for both processes.

PAPERS

The choice of papers available to printmakers is wide. Papers vary in texture, colour and weight. The paper choice, particularly in respect to colour (there are many shades from white through off-white to cream) is important and can really affect the printed image. For this reason it always worth experimenting by printing an image on different papers.

Mould-made papers are the most useful for printmakers. They are made predominantly of cotton fibre, not wood pulp. Cotton fibre stretches under pressure, whereas wood pulp tends to compress. Mould-made paper is acid-free, meaning the paper will not yellow with age. It is distinguished by two deckle edges (the characteristic fringed edge formed as it is made in the mould) and two hand-torn edges. The most useful and stable weight for printmaking is 300 gsm (grams per metre).

Paper varies in the amount of size it contains. Size gives paper its strength and affects how the paper behaves, particularly when it is dampened with water.

It is difficult to categorise exactly which paper suits which printing medium, but the following are a few examples of good printmaking papers suited to all mediums: Velin Arches, Velin BFK Rives, Somerset, Fabriano Rosaspina.

TIP WITH SCREENPRINTING (WATER-BASED), DUE TO THE RISK OF THE WATER CONTENT IN THE INK COCKLING THE PAPER, CHOOSE PAPERS THAT ARE EXTERNALLY SIZED (TUB-SIZED). A SMOOTH SURFACE IS ALSO RECOMMENDED.

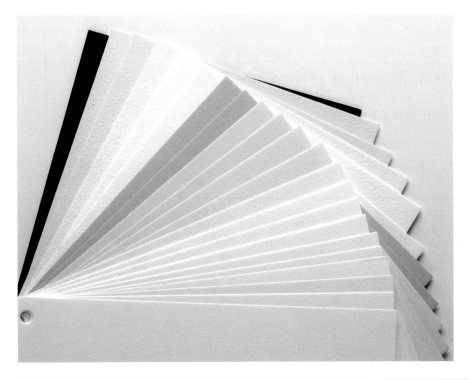

Paper manufacturers produce paper swatches from which to select. This is a sample swatch from the Somerset range.

HEALTH AND SAFETY

Equip yourself with basic personal protective equipment – eyeglasses, a dust mask and plastic, disposable gloves. Wear eye protection at all times when using acids. Wear a facemask when handling fine powders or pigments. Use protective gloves when handling solvents and other chemicals. Wear long, heavy-duty gloves when preparing any acids.

USING PRESSES

It is important to consider the physical aspects of printmaking. Some materials are heavy, for instance litho stones and mill packets of paper. These are best handled by two people.

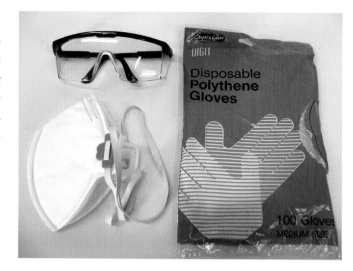

Basic personal safety equipment.

It is important to consider the way that machinery is used, so as to avoid injury. Always ask an experienced person for a demonstration if you are using unfamiliar machinery for the first time. When adjusting or placing the blankets in a press, always ensure that the press bed is at midpoint and therefore balanced between the rollers. This negates any possible risk of the press bed sliding out.

I see so many people turning an etching press standing in a posture that puts strain on the lower back. Stand square on to the press handle and grip the handle with both hands. The drive comes from the leg and arm muscles, not the back. Keep both hands on the handle at all times and do not try abruptly to stop the press wheel.

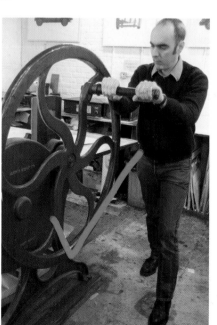
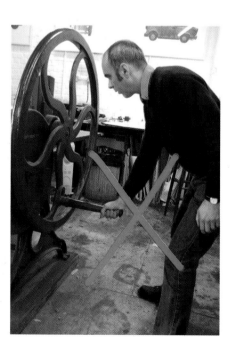

2 Drypoint

DRYPOINT IS A NON-ACID INTAGLIO TECHNIQUE. To make a drypoint, marks are scratched directly into the surface of a plate made of card, plastic or metal. A sharp metal tool referred to as a drypoint needle is used. As the marks are incised into the plate's surface a burr is displaced. When the plate is inked, ink is held not only in the groove created below the surface but also by the burr that is pushed up. The resulting printed mark has a characteristic velvety look.

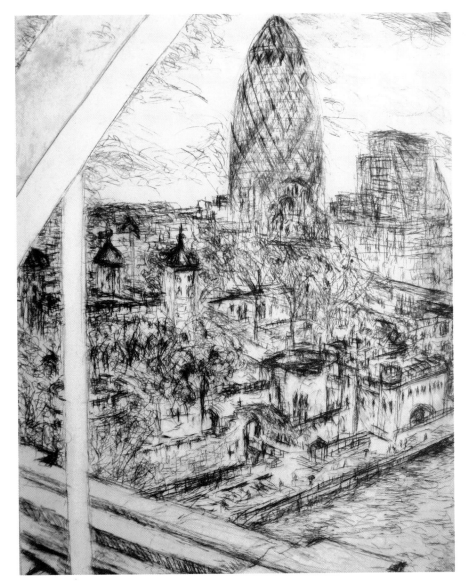

Guerkin

Rachel Lindsey-Clark, 2006. Drypoint on zinc, 20 x 30 cm (8 x 12 in.)

The tone and quality of mark in a drypoint is controlled by hand pressure. For example, by pressing very hard with the needle a deeper groove, and larger burr, is created. This in turn will hold a greater quantity of ink, resulting in a very dark printed line. In an etching or an engraving the ink is held only below the surface of the plate, resulting in a printed mark that has a clean, hard-edged appearance.

Drypoints are printed onto dampened paper using an etching press. The intense pressure needed to print a drypoint means it is not possible to print one by hand.

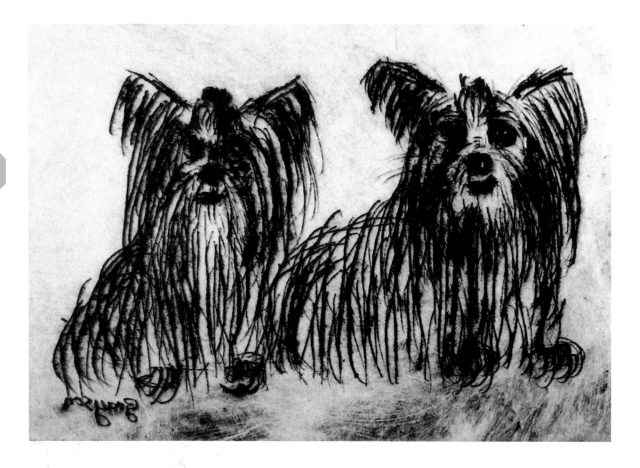

DRYPOINT ON CARDBOARD

Using card is a great way to introduce the principle of drypoint and intaglio printing. It is quick, easy to work and cheap compared to using metal plates. Drypoint card can be purchased from printmaking suppliers or you can make it yourself if you have access to an office laminating machine. It consists of thin card (approximately 0.5 mm thick) with a plastic laminated surface on one side. It has the feel of the card used in a breakfast-cereal carton.

This portrait of a pair of Yorkshire terriers is a fine example of the fuzzy, velvety line produced from the drypoint card. Note also that some ink has been left towards the bottom of the image to lend a more dramatic effect or 'weight' to the composition. This inking is referred to as 'plate tone' and will be discussed further in chapter 3, Etching (p.27).

Taking a drypoint needle, in this case our homemade 6-inch nail, scratch into the laminated surface of the card. You need to press hard enough to break the plastic surface. You should be able to feel a fuzzy burr of card with your fingertip.

With drypoint card it is possible to create areas of dark tone together with line. To do this it is necessary to peel or scrape back areas of the plastic surface to reveal the card underneath. First define the shape required by scratching with the needlepoint. Then carefully peel back the laminated surface.

When ink is rubbed onto the surface it is held in the line but wipes clean from the plastic surface.

The peeled section with ink rubbed into it.

Untitled

Kiki Streitberger, 2007. Drypoint on card, 14 x 11 cm (5½ x 4¼ in.). An example of the 'peel technique' to create the night sky, windows and street.

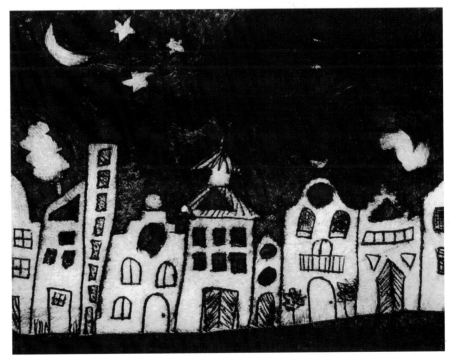

DRYPOINT ON METAL

Drypoint onto a metal plate is the best option in terms of being able to yield a consistent number of prints for a small edition. Three metals – from softest to hardest: aluminium, zinc and copper – can be used. Steel is seldom used for drypoint as it is very hard to work.

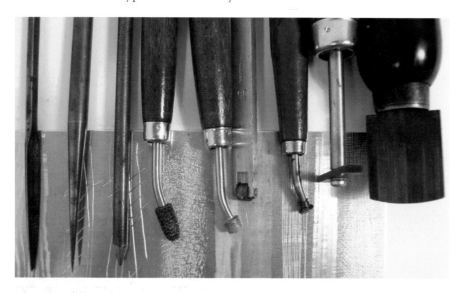

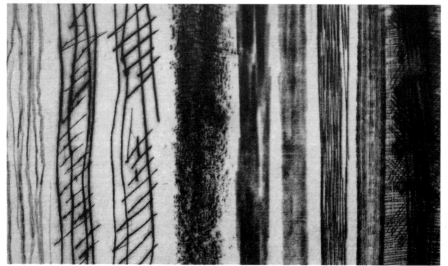

In these two pictures I have shown an aluminium plate with a selection of marks from a variety of tools [from left to right]: Scraper, drypoint needle, sharpened nail, irregular roulette, fine roulette, medium drum roulette, line roulette, halftone rake, mezzotint rocker.
The bottom picture illustrates how the marks look when printed.

Drypoint relies on the fact that a burr of metal is forced up when you scratch into the plate surface. The displaced burr holds ink, as does the groove made in the surface of the metal. The ink trapped under the burr gives the drypoint line its characteristic velvety appearance, which is quite different from the 'hard' line typical of an etched mark. However, during printing, due to a combination of wiping the plate and the pressure of the roller of the press, the burr begins to wear down. Thus each subsequent pull becomes slightly lighter in appearance. For this reason, a collector of drypoints will always be keen to purchase an early number in the edition.

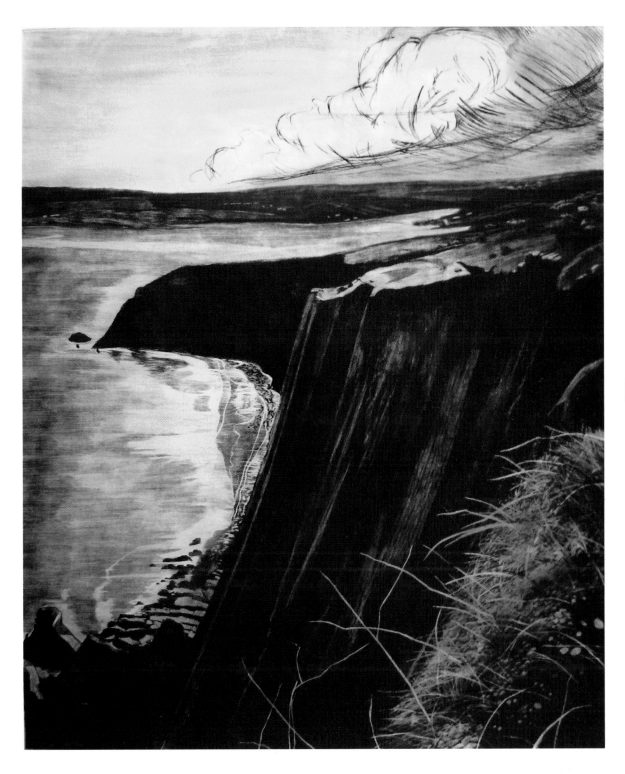

Saint David's Bay, Wales

Melvyn Petterson, 2008. Drypoint on aluminium, 76 x 90 cm (30 x 36 in.).

An irregular roulette working an aluminium plate.

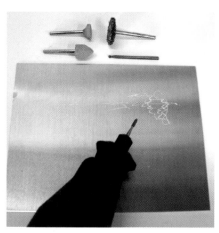

A variable-speed rotary tool and a selection of tool heads.

A printed example from an aluminium plate showing the vibrant creative marks possible with a rotary power tool.

It is impossible to say how many prints a drypointed metal plate will yield as it depends on the nature of the marks created and how the plate is wiped (drypoint plates should be gently wiped). If you require an edition of anything over 30 in number, then you should definitely use copper. Aluminium or zinc are good options for a low edition of between 10 and 20 prints. Aluminium is cheaper and easier to obtain – it can often be purchased in DIY outlets.

A wide range of tools can be used to work a plate; in fact any instrument capable of scratching the plate's surface, thereby leaving a mark which will hold ink.

A modern addition to traditional tools is the variable-speed rotary tool. These are multipurpose workshop tools used for a variety of tasks such as engraving, sanding and polishing. These tools plug into mains electricity and come supplied with a variety of assorted tool heads, most of which can be used to work a metal plate surface.

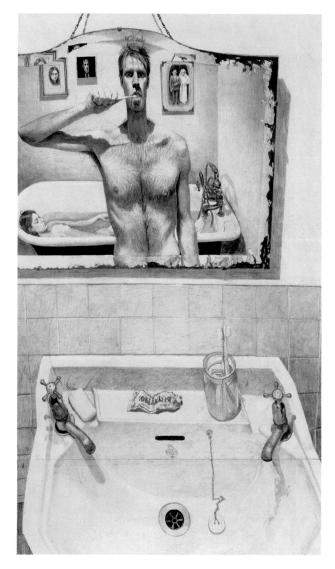

Domestic Scene

Stuart Pearson-Wright, 2006. Drypoint on copper, 58 x 100 cm (23 x 39½ in.)

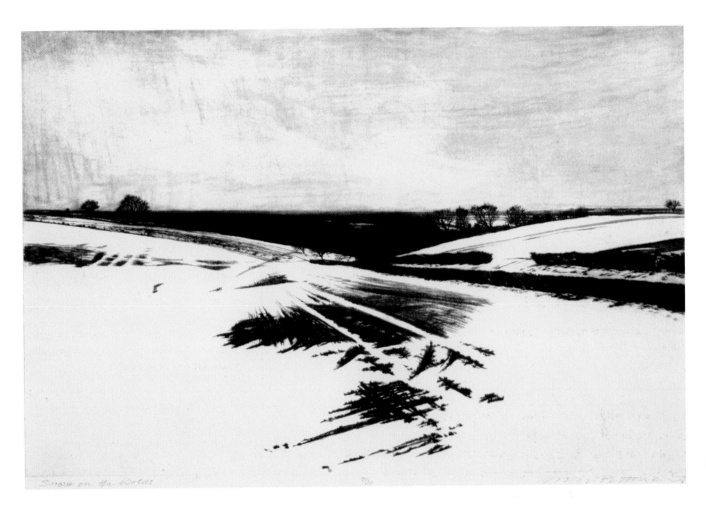

Snow on the Wolds

Melvyn Petterson, 1998. Drypoint on copper,
90 x 60 cm (35½ x 23½ in.).

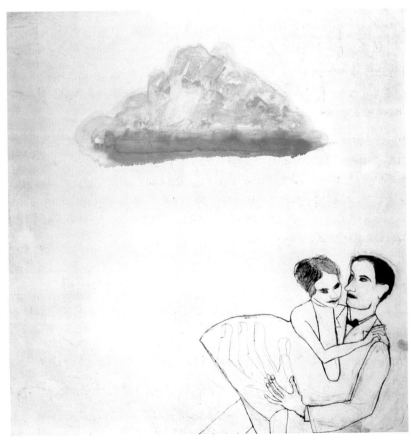

Mayakorsky &
Lily Brink

Kate Boxer, 2007. Drypoint on aluminium
printed onto hand-coloured Japanese paper,
70 x 70 cm (27½ x 27½ in.).

DRYPOINT ON PLASTIC

Using acrylic sheet is another inexpensive way to produce drypoint prints. An advantage with this approach to drypoint is that because the plastic sheet is transparent it is possible to utilise a photograph or a drawing in a sketchbook by laying the sheet on it and tracing the image composition using a permanent marker.

Acrylic sheet can be purchased from large DIY stores; it is used for window panes in greenhouses and outbuildings. The material will be supplied with cutting instructions. You will need a heavy duty craft knife and a straight edge. To cut the plastic, mark the required shape with a permanent marker. Using the straight edge to guide the blade, score repeatedly with the knife. When you have scored four fifths of the way through the acrylic sheet, it should be possible to snap the length on the edge of a table. File off any burr created during cutting and bevel the edges and corners of the plate.

In this example I am using a photograph of St Paul's Cathedral at night. The plastic is placed over the photograph and the main composition is traced using a fine-tipped permanent marker.

The completed plastic with tracing is placed over white paper as this makes it easier to see the marks being engraved into the surface.

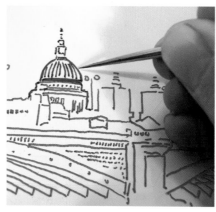

Using a drypoint needle, the main composition is scratched into the plastic.

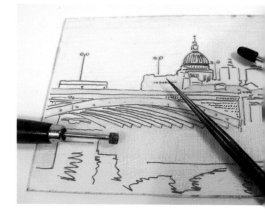

Two types of roulette are used to create the required tones. An irregular roulette (top right) is used for large areas such as the sky. A fine roulette (left) is used for finer shading. The darkest areas are created using a combination of roulette and needled lines hatched close together.

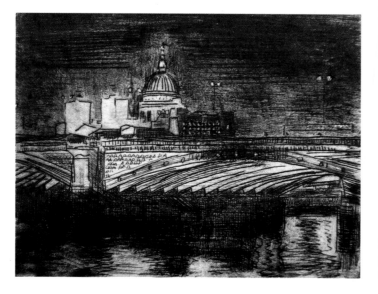

The finished print is pulled onto off-white paper using a warm ink mixed from black and burnt umber.

3 Etching

ETCHING IS STILL THE MOST PRACTISED of the intaglio techniques. The term intaglio, meaning to cut or incise below the surface, embraces the largest number of printmaking techniques. These include non-acid techniques such as drypoint, engraving and collagraph, as well as the etching techniques of hard ground and soft ground.

HARD-GROUND ETCHING

The etching process itself has changed very little over the past 400 years. The principle behind etching is that grooves are etched or bitten into a metal plate through an acid-resistant ground using a mordant or acid.

A ground of wax or acrylic is laid onto a metal plate, and a sharp point is used to scratch through the wax ground to reveal the metal plate. The drawn plate is then submerged in acid, which bites the metal where it has been exposed. The action of the acid creates grooves in the metal, which will then hold ink. The ink is transferred from the plate to the paper using very heavy pressure applied by the rollers on a press.

Wax grounds are still commonly used on etching plates due to the drawing quality that they impart. Acrylic grounds have recently been introduced; these are liquid and flow over the plate coating the surface. Acrylic grounds have the advantages of not needing a hotplate, and they also cut down the use of solvents. Most printmakers still use wax grounds, finding them more sensitive to the variations and subtleties possible in mark-making.

The three metals used for etching are steel, zinc and copper. For the inexperienced etcher I would recommend beginning with polished zinc. Zinc is cheaper than copper and is generally faster to process. Steel is a very economical choice, particularly for large-scale work. However, it has the disadvantage of a grainy surface that produces prints with a slight overall tone which can be off-putting for the beginner.

I would also recommend buying zinc and copper that has been polished and plastic-coated on one side. This ensures a scratch-free and clean surface to begin with. A good printmaking supplier will sell plates for etching pre-cut to a variety of standard sizes. If you have access to a treadle metal-cutting guillotine, then buying the largest standard plates is the most cost-effective approach.

Flow-coating a degreased zinc plate with acrylic ground.

ACIDS

Each metal must have its own acid bath. The most commonly used acid mixes are listed below. Nitric acid must only be used in a studio environment equipped with an acid-fume extraction system. Ferric chloride and copper sulphate can be used without an extraction system, as they do not give off noxious fumes.

When using acid, even in its diluted state, you should always wear eye protection and gloves. Acids should be used in heavy-duty plastic trays and stored clearly labelled in their appropriate containers. When mixing acid always put the water in first and then add the acid, to avoid an adverse chemical reaction.

Different acids take different lengths of time to bite certain metals. The only way to be exact is to make a test strip showing various biting times.

ACID RECIPES (and approximate biting time for a strong line)

Zinc

Copper Sulphate crystals [$CuSO_4$] 50 to 100 g (1¾ to 3½ oz) and 1 l (US 2 pt 2 fl. oz) water for 1 hour.

Alternative: 1 part nitric acid and 10 parts water for 20 minutes.

Copper

1 part ferric-chloride solution and 2 parts water for 1½ hours.

Steel

1 part nitric acid and 8 parts water for 40 minutes.

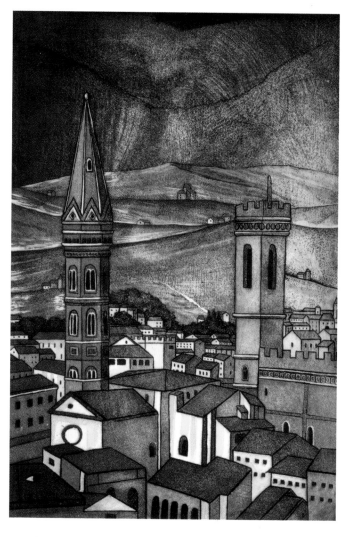

Village Perché

Meg Dutton, 2007. Etching on zinc with hand-colouring, 40 x 60 cm (16 x 24 in.).

Once your plate is cut to the required size, the first stage is to remove the plastic coating.

Before a ground can be laid, the plate must be thoroughly degreased. This is done with a mixture of whiting powder (chalk) mixed into a paste with water that has had a few drops of household ammonia added to it.

The whiting powder is placed into a tray.

The water/ammonia mix is added to the chalk and mixed to a thick paste.

Place the plate in the sink. (It is good to put down strips of 2 x 1 in. wood in the sink to raise the plate off the sink bottom. This minimises the risk of picking up grit that might scratch the plate.) Then take a piece of clean cotton wool and rub the chalk paste over the plate surface.

Rinse away the chalk with running water. When water runs off the surface in an unbroken film, the plate is properly degreased. The plate should then be dried using a fan or hairdryer.

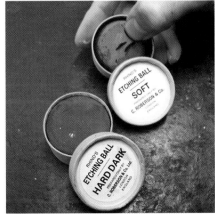

Wax grounds are sold in solid balls or cakes. They are supplied in hard and soft grades. In a busy workshop the two can become muddled up or wrongly labelled, so always check by digging your nail into the wax – it will be obvious which is hard and which is soft.

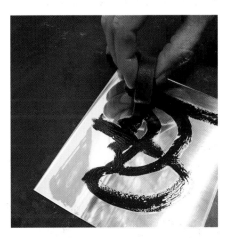

Place the dry, degreased plate onto the hotplate. Taking the hard ground, melt some wax onto the plate surface. If the wax does not melt easily the hotplate needs to be hotter.

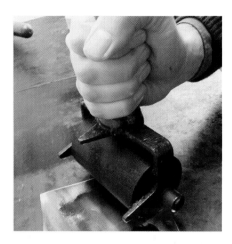

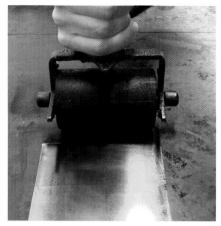

Take the roller and begin rolling the ground into an even layer. It is essential to have separate rollers for hard and soft grounds.

Thinly and evenly cover the entire plate surface. Carefully push the plate from the hotplate using a palette knife so that it can cool down.

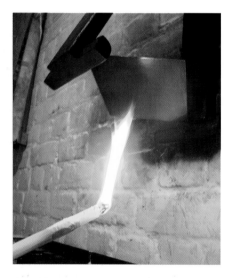

The plate is now smoked using six wax tapers tied together. The waxed plate is suspended upside down on a hinged bracket that is fixed to the wall. Alternatively, the plate can be held using a hand vice. Smoking adds carbon to the wax surface. This not only darkens the ground, making the drawn marks more visible, but has the effect of hardening the ground against the action of the acid. The plate will be extremely hot, so leave it for at least five minutes to cool.

The plate is now ready for drawing. Any point or texture that removes the wax and reveals the metal can be utilised. Do not be afraid to experiment with mark-making. I always recommend taking a small metal offcut and playing with mark-making using various tools as a way of finding out the possibilities of the process.

The example here illustrates the making of an experimental test plate.

 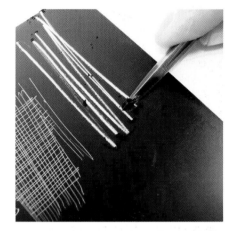

Drawing using the homemade tools demonstrated on pages 14 and 15.

Making marks with the edge of a scraping tool.

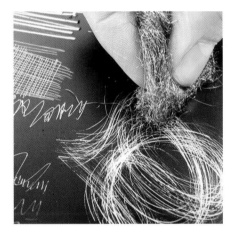 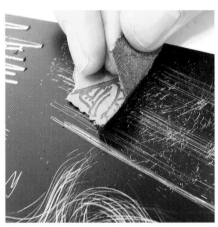

Creating textures using steel wool and coarse sandpaper.

The mark-making is completed and the back of the plate is protected from the acid during biting using strips of brown packing tape. The tape method is quick to apply and remove, and cuts down on solvent use, removing solvent-based stop-outs. Alternatively, the back can be stopped out by painting on varnish such as bituminous paint or straw-hat varnish, though the appropriate solvents will be needed to remove these substances.

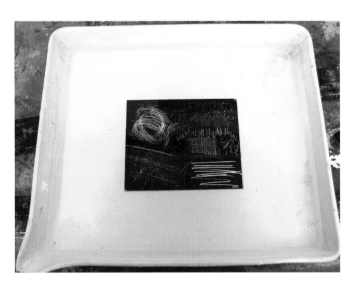

LEFT The plate is then submerged into a bath of acid. For this demonstration the zinc was bitten in copper sulphate. As sediment appears over the lines it is brushed away with a feather; alternatively, the plate can be rinsed with water. For further reading on copper-sulphate biting, on the internet, search under 'copper sulphate etch' or 'Bordeaux etch'.

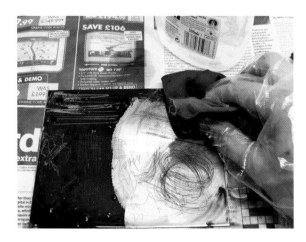

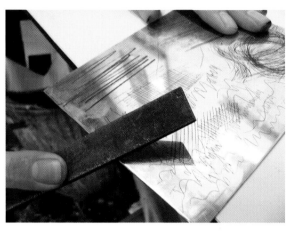

The plate is removed from the bath after one hour and rinsed with water. The wax ground is then cleaned off using cotton rags and white spirit.

The edges of the plate are now filed to a bevel. Hold the plate with one hand and file at an angle of approximately 45 degrees. Take care to brush away any filings from the plate surface, as these could cause scratches during inking.

RIGHT **The plate is inked with black etching ink using a strip of mount card.**

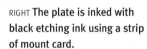

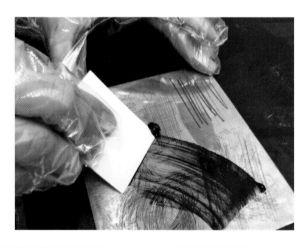

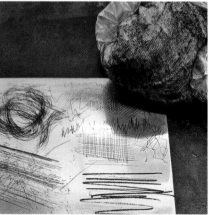

The fully inked plate is then wiped with a pad of scrim or tarlatan. It is usual to proceed with three pieces of clean scrim.

The first takes off the majority of the ink and becomes very soiled. Then progress to a second clean piece and finish wiping with another clean piece of scrim.

Each scrim pad should be large enough to form a pad that fits comfortably in the palm of your hand. Wipe gently in a circular motion.

Prior to printing, wipe the edges of the plate with your finger through a clean piece of rag.

Paper is soaked in clean water for approximately 10 minutes. Soaking fluffs up the fibres and softens the paper so that it can mould into the grooves etched in the plate. Before printing, the paper should be blotted using blotting paper or newsprint so that no surface moisture is visible.

The plate is placed onto a sheet of tissue on the press bed. The damp paper is then lowered onto the plate.

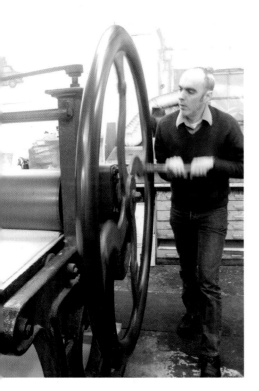

The blankets are placed down over the plate with the paper in place, and the press is slowly wound.

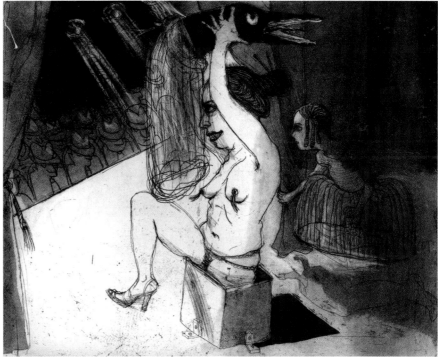

Petit Mort 14

Marcelle Hanselaar, 2005. Etching, 20 x 25 cm (8 x 10 in.).

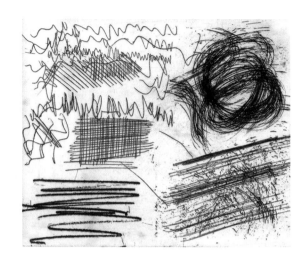

To help you create plate tone, it is worth adding a little copperplate oil to your ink.

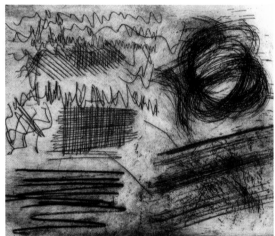

RIGHT, TOP **The print is pulled from the plate. This has been wiped very clean so that the marks can be judged. Often clean-wiped prints can look a little stark, so it is worth experimenting with wiping by leaving a thin film of ink on the plate surface; this is referred to as plate tone. (It is also quite difficult to achieve from a polished plate, with the result that each print will vary.)**

RIGHT **The same plate printed, leaving plate tone. The whole effect is richer and has more life. Wiping can make or break an image.**

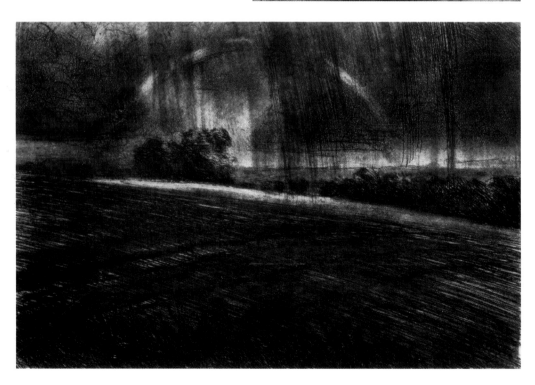

Rainbow IV

Melvyn Petterson, 2007.
Etching on copper, 18 x 12 cm
(7 x 4¾ in.).

DRYING PRINTS

Finished etchings must be dried under weight otherwise they will dry cockled. Lay a sheet of tissue over the ink surface then place the print between two pieces of clean blotting paper. Cover everything with a heavy board and weights. The etchings will take four to five days to dry thoroughly.

If you need to dry etchings quickly, then immediately after printing tape the print to a flat board using gum-strip tape. Cut four strips, immerse each one in water and tape the paper to the board along each edge. The print will dry in about an hour.

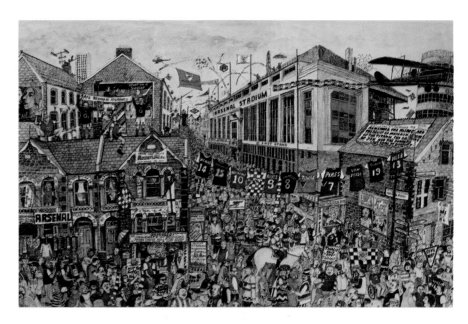

The Last Match at Highbury

Mick Davies, 2007. Etching on zinc with hand-colouring, 50 x 70 cm (19½ x 27½ in.).

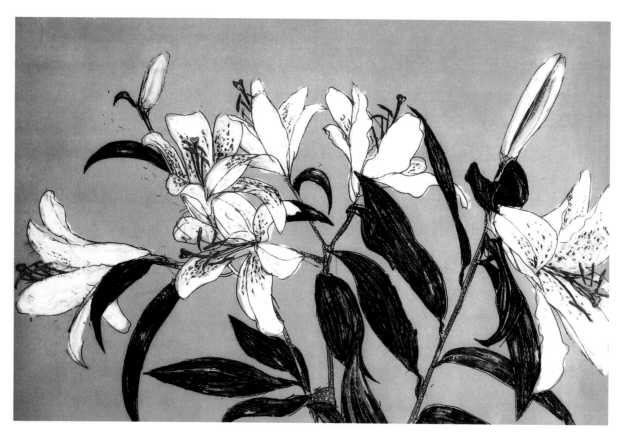

Lilium

Peter Wareham, 2006. Etching on steel, 38 x 25 cm (15 x 10 in.).

INKING A COLOUR ETCHING FROM A SINGLE PLATE

It is possible to ink a single plate using many colours. This is referred to as *à la poupée* printing – literally, with a dolly. In the Victorian era it was not unusual to see an intaglio print from a single plate that had been inked using anything from 5 to 50 colours.

A variety of inking 'tools' – the dollies – can be used to apply the ink. These could be scrim-wrapped over the forefinger, strips of mount card, or cotton buds for very small areas.

With this technique colours must be carefully thought out and mixed, as they will inevitably blend together when they are scrim-wiped. If a hard-edge multicolour effect is needed then more than one plate must be used.

In this example small pieces of mount board cut to size with scissors are used to apply the colours. Bryan Poole is a New Zealand-born botanical and natural-history artist. The copperplate was etched through hard-ground wax using ferric chloride acid. The lettering was engraved with a burin after completion of the etching stage.

It is always important to keep colour notes so that the colours can be accurately mixed again when required. It is very easy to forget colour mixtures several months or even years down the line. Editioned prints should be as consistent as possible. Make notes, stating the colour and ink make/supplier (this is important as colours vary from supplier to supplier even though they have the same colour name). Write down the approximate ink mixtures by percentage – for example, 'This green is 75% mid-green, 25% primrose yellow'. Rub a swatch of the colour next to the written notes with your finger or using a push knife. Make the notes on a scrap piece of the actual printing paper that you will be using for the edition as the colours will look different on other colour shades of paper.

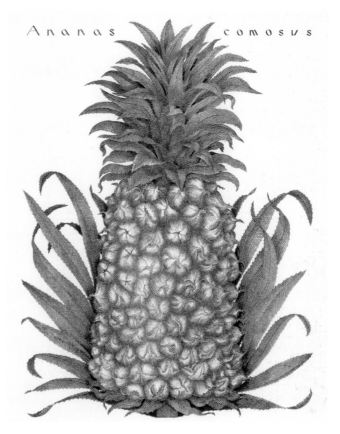

Ananas Comosus

Bryan Poole. Etching with engraving, 56 x 76 cm (22 x 30 in.).

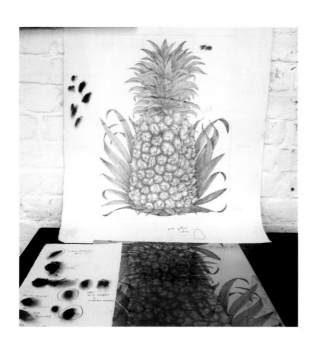

Copperplate, black-and-white proof marked with inking notes and the colour swatches.

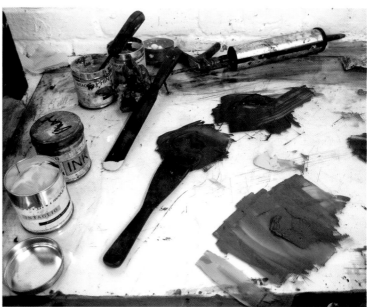

The colours are mixed onto a glass surface. For the pineapple print, four colours are needed: two greens, a brown and yellow ochre.

TIP ALWAYS MIX MORE INK THAN YOU THINK YOU WILL NEED. IT IS TIME-CONSUMING TO REMIX INK IF YOU RUN OUT DURING THE DAY'S PRINTING. EXCESS INK CAN BE WRAPPED IN PLASTIC OR PUT INTO A TUBE, AND KEPT FOR ANOTHER DAY'S PRINTING.

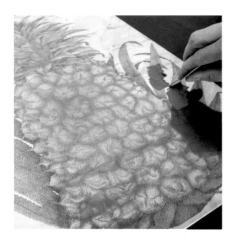

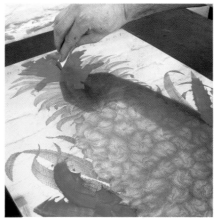

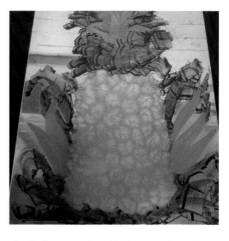

The light green ink is carded onto the plate where the green highlights on the leaves are needed.

The first colour applied to the plate. This colour is then scrim wiped in the usual manner. See page 32 'Wiping an Intaglio Plate'.

The darker green is added to complete the inking of the leaves. Again this is scrim wiped, taking care to wipe away from the light green that was applied to the plate first.

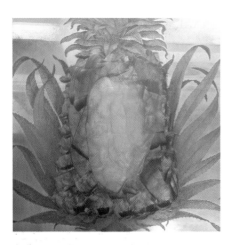

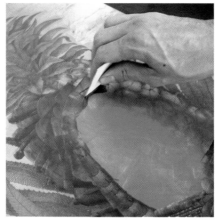

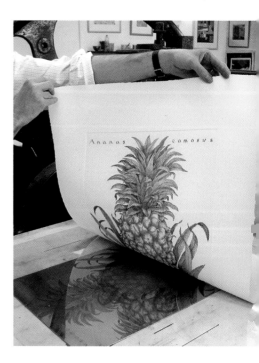

The body of the pineapple is inked using brown and yellow ochre. The ochre is applied first, to achieve a highlight which gives 'roundness and form' to the pineapple shape. The darker brown is added around the ochre. The lettering is also inked in brown at this time.

The fully inked plate prior to scrim-wiping. The brown is carefully wiped using a smaller pad of scrim to ensure it is not wiped into the green leaves. The brown and the ochre are rubbed together where they touch to achieve an even blend of colour. The whole plate is then carefully wiped with tissue paper so that no ink is left on the background areas, as these must print paper white.

The final print being pulled from the plate. The paper used is white textured 'Somerset' 300gsm.

SOFT-GROUND ETCHING

Soft-ground etching was originally developed as a way of reproducing pencil-type marks on an etched plate. As well as pencil, many other types of materials can be used to create patterns and textures. The soft wax has a similar appearance to hard-ground wax, but the addition of tallow to the mix means the soft wax never dries. The wax is laid on a plate and, using very little heat, textures are pressed into it. The textures pull the soft wax from the surface revealing the metal surface of the plate, which is then etched in a bath of acid.

The technique can be used on its own or combined with other etching techniques.

ROLLING SOFT GROUND

RIGHT **The plate is placed on a warm hotplate and the soft wax is melted on. You won't need to degrease the plate, as the wax is inherently greasy.**

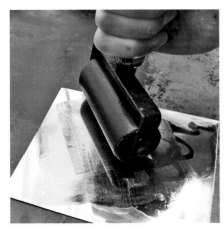

Taking a roller (a separate roller is kept just for this process), the wax is evenly and thinly rolled over the plate surface.

To make pencil marks, place a sheet of newsprint or other thin smooth paper over the plate. It is a good idea to tape down the sheet so that it doesn't move. Drawing onto the newsprint pulls the wax from the plate surface, leaving behind characteristic pencil marks.

The paper is lifted to check progress.

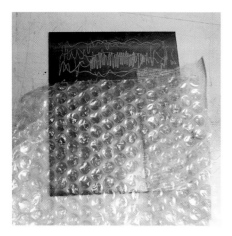

Textures of scrim and bubble wrap are laid over the waxed plate. The plate is then covered with greaseproof baking paper and run through the etching press. The grease-proof paper prevents wax being lifted onto the press blankets. Set the press for less pressure than would normally be used for printing. If the press pressure is too tight the soft ground that is not covered by the object may pull off and stick to the grease-proof sheet.

A close-up showing the impression of the bubble wrap and scrim prior to etching. The back of the plate is then stopped out using varnish before being submerged in the bath of acid appropriate for the metal used.

An impression from the inked plate.

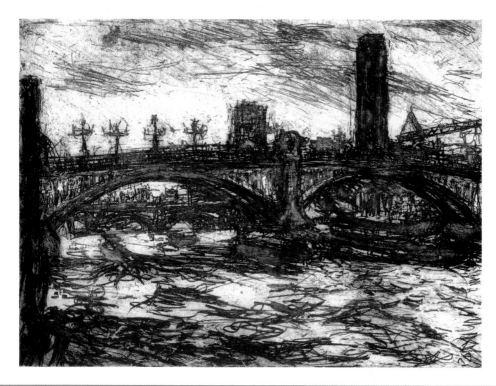

Southwark Bridge

Rachel Lindsey-Clark, 2006.
Soft ground on zinc, 35 x 26 cm
(13¾ x 10¼ in.).

This example illustrates soft ground using a natural material – a native New Zealand fern leaf, courtesy of Helena Poole.

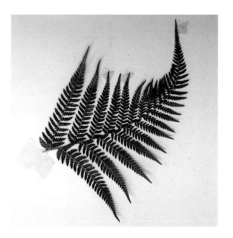

RIGHT The leaf has been taped to thin card and flattened between heavy books for a few days.

The leaf is carefully laid onto a plate that has been recently rolled with a soft ground

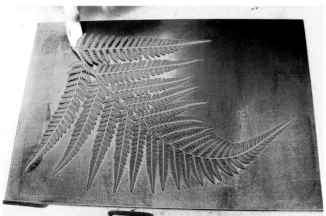

The plate is run through the press. Discard the greaseproof paper and carefully lift the object from the plate. A pen knife is used in this example to lift the fern leaf.

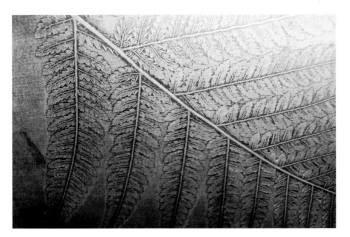

The soft-ground plate showing the pressed impression of the fern leaf. The copperplate was now etched for 40 minutes in ferric-chloride acid.

The first printed proof; the plate was inked in a dark-green colour.

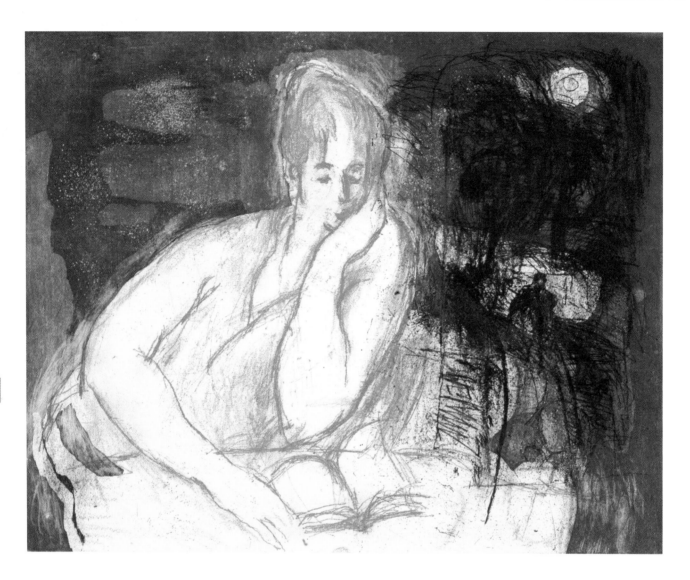

Girl Reading

Susan Einzig, 2001. Soft ground and aquatint on copper, 30 x 26 cm (12 x 10¼ in.).

4 Flexograph ~ *Photopolymer Gravure*

FLEXOGRAPH, SOMETIMES CALLED 'SOLAR PLATE', can be used for intaglio or for relief-printing. The technique is becoming increasingly appreciated because of the possibilities it offers for both hand-drawn marks and photographic imagery. The major plus point in using these plates is that they require no chemicals to process them; only tap water is used. Weather permitting, the plates can be exposed using sunlight, or by the usual, more dependable method with a standard UV exposure unit.

Flexograph plate consists of a light-sensitive polymer layer held on a steel backing. The plate is exposed to a positive, which can take the form of an acetate produced by a photocopier or an inkjet printer. A hand-drawn or painted image on transparent drafting film can also be used.

Flexo image by Richard Wathen being pulled by Megan Fishpool at Artichoke Print Workshop.

HAND-DRAWN OR PAINTED POSITIVES

A wide range of conventional drawing media can be used. The drawing material needs to block out light, so it is best to use black in all cases. The more opaque the material, the better. Dry materials such as oil pastel, lithographic crayons or graphite pencils, fluids including acrylic paint and drawing ink can be used. The drawing should be made on drafting film, the slightly grainy plastic film that architects use.

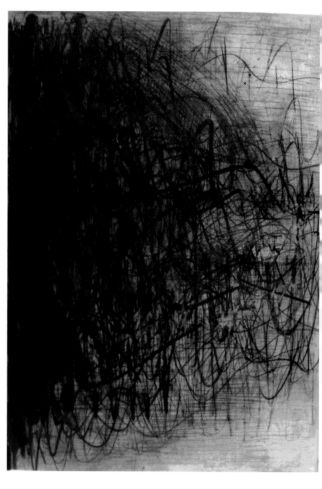

Untitled intaglio print, Colin Gale, 2006. Printed from one flexograph plate exposed from a hand-drawn drafting film with a background printed from two etched steel plates, 40 x 60 cm (16 x 24 in.).

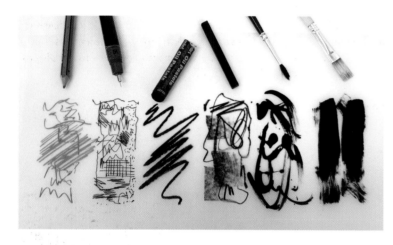

From left to right: 2B pencil, Rotring pen, oil pastel, litho crayon, drawing ink, acrylic paint.

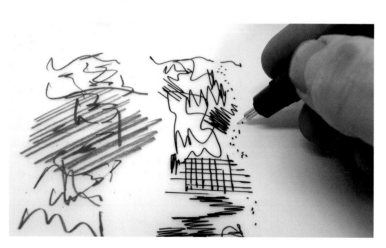

The fine lines produced by a Rotring ink pen.

Remove the plastic protective film from the flexograph plate.

The plate is first exposed to a halftone screen. This ensures that a dot pattern remains in the marks to hold the printing ink. The plate is then exposed for six and a half minutes (exposure times will vary with different machines. It is necessary to make some tests to determine the correct exposure time. As most exposure units are studio-based there will probably be a person with experience who can offer a guide time for exposing.).

The plate is now exposed to the drawing. The drawing is placed faced up on the glass and the plate is positioned on top. The exposure time given here was nine minutes, though this will vary from image to image and according to the light source used.

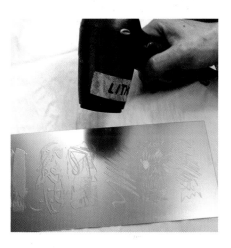

The plate is placed into a tray of lukewarm water (20º–25ºC/68º–77º F). Leave it to sit for the first minute. For the second minute rub the plate gently using a sponge. The plate will need approximately three minutes in total to develop.

Remove the plate from the water and quickly blot the excess water using newsprint or newspaper.

Dry the plate using a hairdryer. Leave the plate in daylight for at least 30 minutes. If the image areas feel dry to the touch and not sticky, then it is ready for printing. Ink the plate as per any intaglio plate.

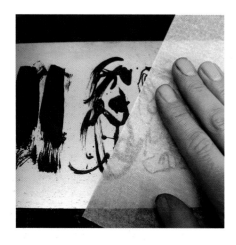

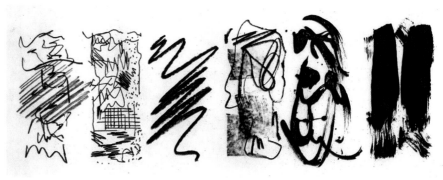

Finish wiping using a piece of tissue and the flat of your hand. This ensures a good crisp print. The plate is then printed onto damp paper through an etching press.

The final print on white paper.

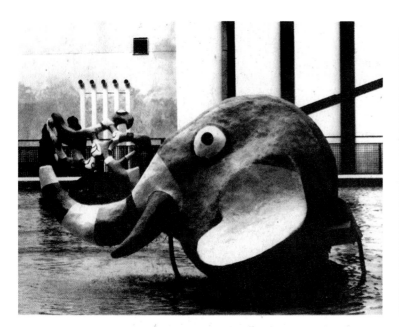

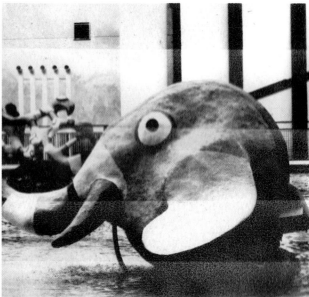

Pompidou

Ana Mendonca, 2006. Flexograph, 12 x 10 cm (4¾ x 4 in.).

The printed test strip for this image was made to determine an exposure time of three minutes (exposed in a UV light box together with a halftone screen).

EXPOSING USING THE SUN

Weather permitting, UV rays from sunlight are good for exposing flexo plates. This is experimental work for which you should adopt a trial-and-error approach. First, you need to make a contact frame. This is to give a good contact between the plate emulsion surface and the positive acetate artwork. A frame slightly larger than A4 is a practical size, as this will accommodate an acetate from the average desktop printer.

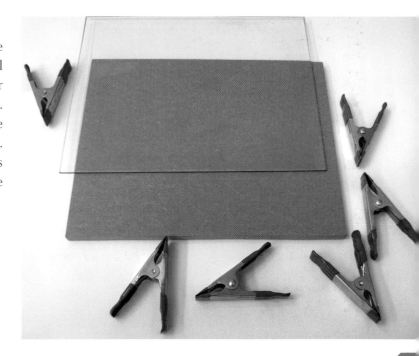

You will need a piece of 2.5 cm (1 in.) MDF (medium-density fibreboard), a sheet of bevelled plate glass at least 4 mm thick, and some sprung clips.

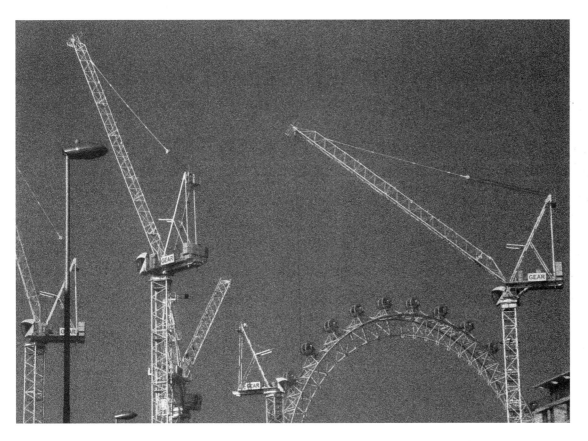

The positive. Inkjet on acetate printed from a digital photograph through Adobe Photoshop. Ensure the positive has lots of grain in the dark areas, using the diffusion dither setting. See Using Digital Photographs for Etching, page 53.

The plate is placed emulsion-side up onto the MDF, with the acetate on top. The glass is secured down using the sprung clips. The frame is placed in direct sunlight to expose it, in this case for 20 minutes.

The exposed plate is developed in warm water for three minutes.

RIGHT The plate is blotted dry with newspaper and quickly dried with a hairdryer.

Cranes near the London Eye

Colin Gale, 2007. Flexograph 20 x 16 cm (8 x 6¼ in.).

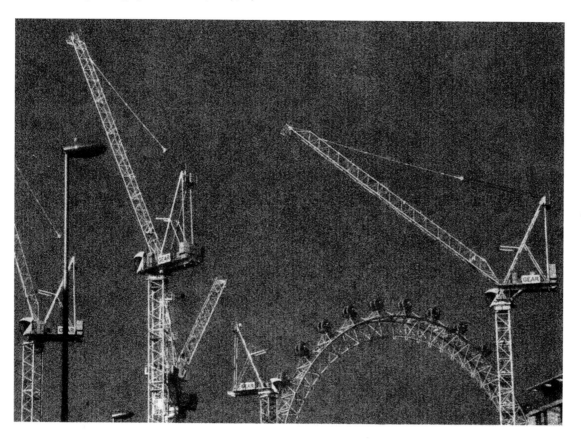

Untitled

Michael McNamara, 2007. Flexograph intaglio, 20 x 15 cm (8 x 6 in.)

Fern

Elaine Pessoa, 2008. Flexograph, 9 x 12 cm
(3½ x 4¾ in.). Intaglio, 20 x 15 cm (8 x 6 in.)

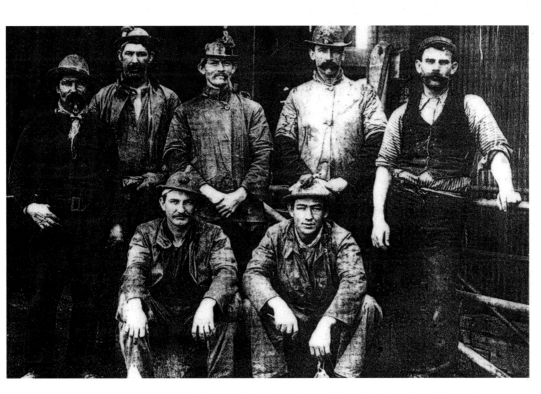

Miners and Engine Drivers Walleroo Mine

Diane Spiers, 2007. Flexograph,
20 x 15 cm (8 x 6 in.).

Landscape

**Morgan Doyle, 2007. Etching on steel,
120 x 90 cm (47 x 35½ in.).**

5 Using Digital Photographs for Etching

THE FOLLOWING PROJECT SHOWS ONE WAY of using digital photographs to make an etching.

Traditional printmaking has an advantage over a purely digital surface, in that an etching has a weight of ink that has been embossed into the paper surface. The etching is beautiful as a physical object in itself, quite apart from the image printed on it. This portrait example shows how to use the computer to generate a positive and to make a photo-etching.

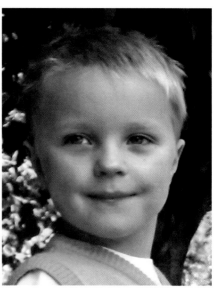

The image is downloaded from a digital camera onto the computer. The digital image is then opened in Photoshop by dragging it onto the Photoshop icon. The entire photograph may be used, or alternatively an area may be selected using the rectangular/ellipse selection tool, then cropped to leave the image you want.

The cropped image is then resized to the required dimensions.

The colour information in the image is then discarded by converting the document into Grayscale. From the top menu – Image – Mode – Grayscale.

The next stage is to pixelate the image. From the top menu select Image – Mode – Bitmap.

Then select the required resolution in pixels/cm and choose Diffusion Dither from the Method option. You will need to experiment with each image to find which resolution appears most satisfactory – 250/cm is a good starting point, but you should also try 200/cm (coarser grain) and 300/cm (fine grain).

The image with Diffusion Dither.

A close-up showing the grain detail of the Diffusion Dither mode. The image is now printed onto acetate using an inkjet printer. It is recommended that you use inkjet acetate with a grainy surface, as this is less likely to smudge than a smooth surface.

PREPARING THE PLATE SURFACE FOR USE WITH THE OUTPUTTED ACETATE

This process works equally well using zinc, copper or steel plates.

The plate is first degreased in the traditional manner. See Etching, page 29.

Using a push knife, spread liquid blue etch emulsion onto a glass sheet.

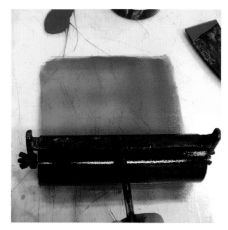

Roll the emulsion into an even layer and coat the plate thinly and evenly. Make sure that no bare metal is visible. Place the coated plate in a darkened cupboard. Stand it face towards the wall. With a hairdryer heat the plate for several minutes, then leave it to stand in the dark for an hour or more. The drying time will vary with atmospheric conditions. When thoroughly touch-dry, the plate is ready for exposure.

EXPOSING THE PLATE

The plate is first exposed to an aquatint halftone screen. This creates a dot structure over the whole plate that in turn will form the bitten tooth (grain) necessary to help hold printing ink.

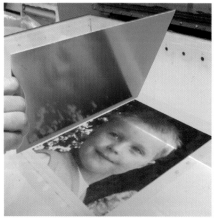

The plate is now exposed to the inkjet positive. The emulsion is hardened where the UV light hits the non-image areas. The image areas stay soft and will develop away in the next stage.

The plate is developed in a bath of sodium carbonate (washing crystals). Mix three to four teaspoons of sodium carbonate in two litres (4¼ pt) of water. This process should take two to three minutes. Make sure bare metal is clearly visible in the image areas.

Remove the plate from the developer and dry quickly using a hairdryer. Allow the plate to stand in daylight for a minimum of 30 minutes to allow it to harden. The plate is then etched in the appropriate acid bath. See Etching, page 28.

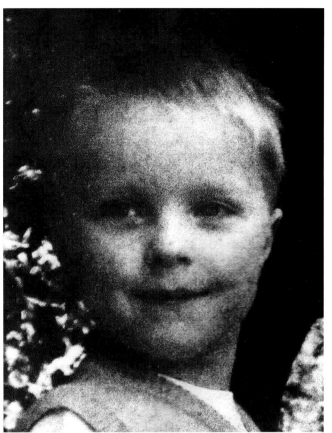

The final printed etching.

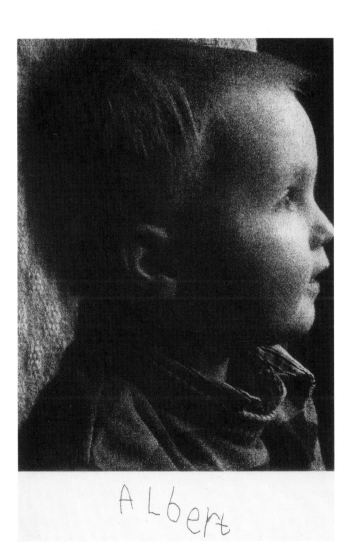

The etching plate is a nice object for display in its own right. The plate has been left with ink still in the lines to heighten the contrast with the metal surface.

Albert

Colin Gale, 2007. Photo-etching printed in sepia, 18 x 28 cm (7 x 11 in).

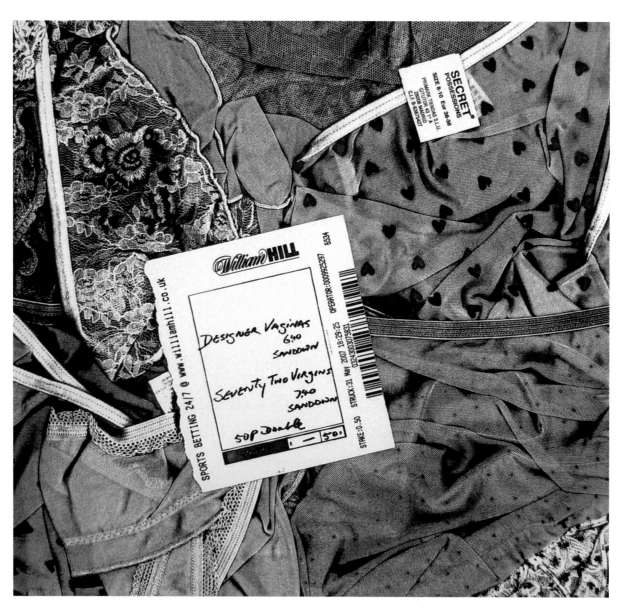

London Wildlife

Tony McCormack, 2007. Etching, 27 x 24 cm (10 x 9½ in.). Garments and a betting slip were arranged and directly scanned to produce the acetate for the photo-etching process.

6 Collagraph

COLLAGRAPH IS A TECHNIQUE ALLOWING PRINTMAKING from a plate made of collaged textures and materials. A wide range of materials such as glues, varnishes, acrylics and textiles can be used to form a contoured surface on a flat base plate of card or metal. Most of these materials can be purchased from a DIY store.

This technique is well suited to artists who love an experimental mixed-media approach. Collagraph can incorporate both intaglio and relief on a single plate. The technique produces heavily embossed, bold, vibrant images.

The base plate for collagraph should be uniformly flat and ideally between 1 and 2 mm thick. Metal, card and Perspex can all be used. The technique is a good way to recycle the back of used etching plates or offcuts of mount card.

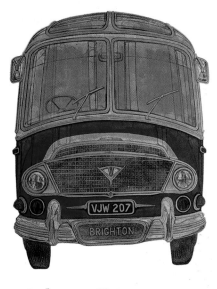

Brighton Bus

Barry Goodman, 2007. Collagraph, 56 x 76 cm (22 x 30 in.).

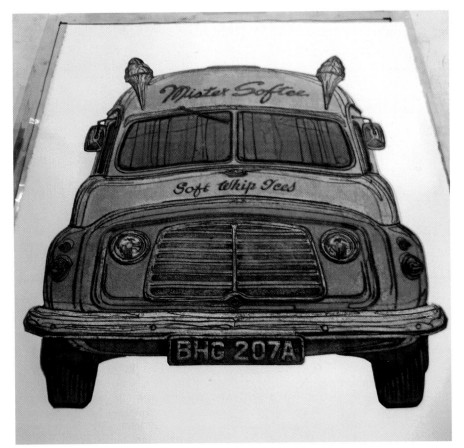

Ice Cream Van

Barry Goodman, 2007. Collagraph using mount board, 56 x 76 cm (22 x 30 in.).

The background colours are inked and assembled like a jigsaw puzzle.

The second plate holds the main detail and is printed in black on top of the previously printed colours.

MAKING A COLLAGRAPH

This example uses mount card for a base and illustrates the use of various glues, gesso and carborundum (aluminium oxide).

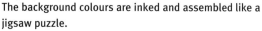

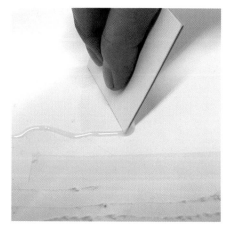

The surface of the card can be worked using sharp tools, for example, a sharpened nail and a craft knife. The nail is used as in the drypoint technique – to scratch into the surface and raise a burr of card. A sharp craft knife or scalpel can be used to lift the shiny card surface, revealing the fibrous card centre which, due to its texture, will hold a layer of ink.

Two-part epoxy resin, as well as being great for sticking down just about anything, can be used to create a smooth raised layer that can be drawn into using the wooden end of a brush or a pencil. Ink is held in the furrows and wipes clean from the epoxy peaks.

Carborundum, or aluminium oxide, is used in the print studio for graining lithographic stones. It will typically be stocked in coarse, medium and fine grades. Carborundum is unsurpassed in its ability to hold heavy deposits of ink. The grains are glued down using strong wood glue or PVA. The carborundum can either be mixed into a paste and painted or carded on, or it can be sprinkled onto an area of glue.

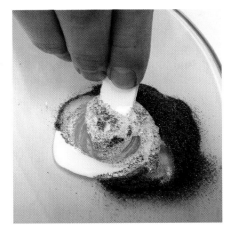

Mixing coarse carborundum with wood glue.

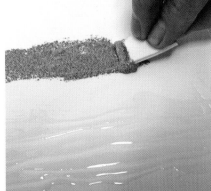

Spreading the mix using card.

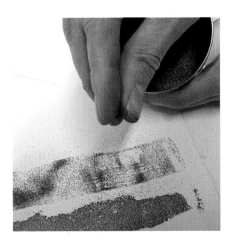

Sprinkling fine carborundum onto an area painted with glue.

Acrylic gesso is used as a primer for board or canvas prior to painting. It is a thick, viscous paste that is excellent for making textures on a collagraph plate. Once applied to the plate surface it can be worked into textures and patterns using various tools.

Gesso being applied with a palette knife.

The knife is pressed into the gesso, leaving impressions and texture.

ABOVE AND BELOW **Gluing down strips of card with PVA to create levels.**

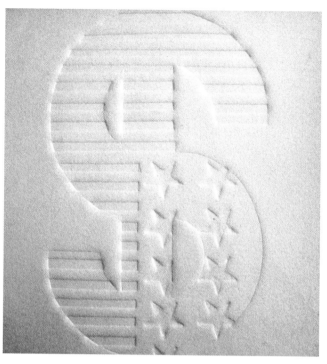

Dollar

Erika Turner-Gale, 1998. Blind emboss (no ink used) from a card plate, 18 x 20 cm (7? x 8 in.).

SEALING THE PLATE

Once the plate is completed it should be left overnight to ensure that the glues and pastes have time to harden properly. When thoroughly dry it is vital that the plate is sealed to ensure stability during inking and printing with dampened paper. Acrylic varnish is a good sealant; it dries in approximately 20 minutes and cleans up with soap and water.

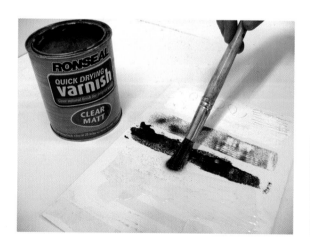

Brushing on acrylic varnish.

The varnish should be thoroughly and evenly brushed on.

INKING

Use intaglio ink applied with card or 'dollies' of scrim (particularly useful for multicoloured work). Scrim-wipe in the usual fashion, taking extra care to work ink into all the crevices and textures.

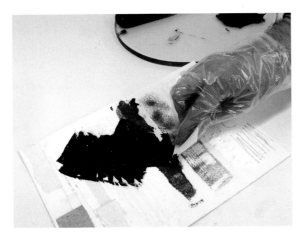

Applying the etching ink.

Scrim-wiping the plate.

The plate is printed onto 300 gram dampened paper using an etching press.

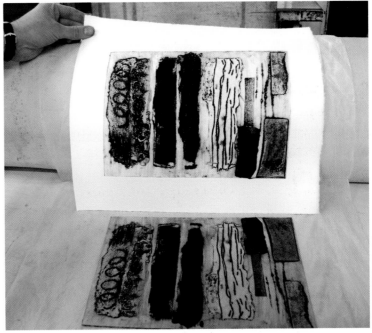

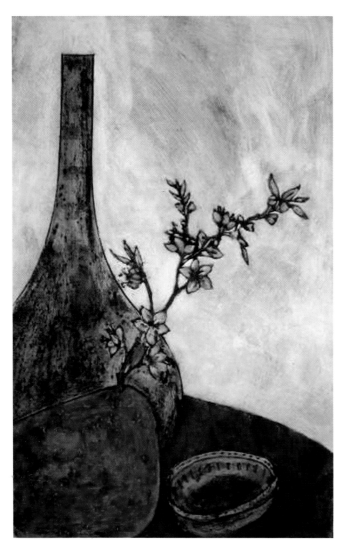

Conran's Pots

Vicky Oldfield, 2005. Collagraph printed in colour from a single-card plate, 29 x 39 cm (11½ x 15½ in.).

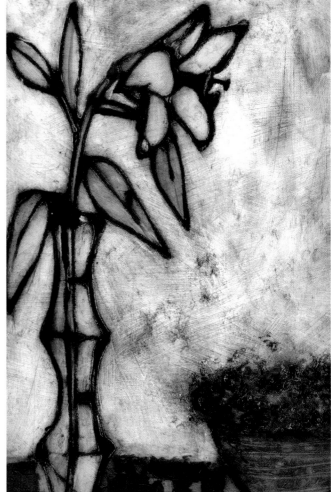

Scented Bowl

Vicky Oldfield, 2005. Collagraph printed in colour from a single-card plate, 29 x 39 cm (11½ x 15½ in.).

Backy

Kate Boxer, 2006. Carborundum on aluminium with hand-colouring, 90 x 60 cm (36 x 24 in.).

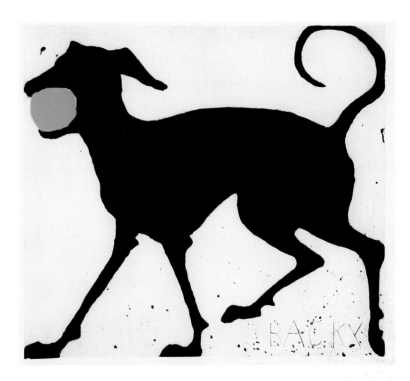

Puddles

Staffan Gnosspelius, 2007. Collagraph on card, 20 x 20 cm (8 x 8 in.).

7 Digital Printmaking

THE HISTORY OF PRINTMAKING TECHNIQUES involves the adoption of commercial print processes by artists. As technology advances, artist-printmakers not only embrace the new, but keep the once-cutting-edge processes of their time alive as they become commercially redundant. To give an example, lithography as a commercial process was invented in 1798 using slabs of Bavarian limestone. Stone was superseded in the 20th century by zinc and aluminium plate and today lithography utilises photo-sensitive aluminium to print everything from magazines to postcards. However, all three of these commercial lithographic transitions are still used today by printmakers.

The latest chapter in printmaking embraces the digital age. Generally speaking, digital technology is used by printmakers in two ways: as a tool to produce artwork positives for traditional photographic printmaking techniques; and for original pieces conceived entirely on the screen and printed out on inkjet printers.

Etchings on zinc, Elizabeth Price, 2006. The images were drawn on the computer and outputted onto acetate. Zinc plates were then coated with blue etch resist before biting in nitric acid. The images were printed on off-white Somerset paper in a graphite-colour ink.

Queque

Steve Mumberson. Digital print, 15 x 8 cm (6 x 3 in.).

The computer can be used to manipulate digital photos, or to mimic the marks of traditional drawing and painting materials. The output is in the form of black and white (greyscale) acetates or paper for photo-etching, photo lithography and photo screenprinting.

Digital prints are printed from inkjet printers of varying formats ranging from A4 sheets to long rolls a metre or more wide. Specialist papers are available from all the main paper manufacturers familiar to most printmakers. Essentially, these papers are the acid-free cotton papers commonly used in printmaking, but with a special surface formulated to take inkjet ink. It should be mentioned at this point that in terms of conservation, inkjet prints are best printed by a specialist bureau that uses archival-standard inks. A print from a domestic/office-standard inkjet printer will usually begin to fade within a year as the ink cartridges are not lightfast.

Chapter 5 (page 52) demonstrates how to use photographs to produce an etching.

A box of A4 fine-art inkjet paper.

Two of the programs which are very popular with artists are Adobe Photoshop and Fractal Design Painter. If you are a beginner to these programs don't be daunted: tours and help sections are built into the programs. Tutor manuals called 'visual quickstart guides' are available for Photoshop. Painter is supplied with its own tutorial booklet. Initially, one of the best ways to learn is simply to experiment and 'play around' with the programs. Remember, it is not necessary to learn the whole program. Many aspects of the program you may never need or use anyway. The main thing is to make them useful for you and your work.

PHOTOSHOP

This is an image-manipulation program. To give you an idea of its usefulness, every photograph and image in this book has been processed through Photoshop. The images have been cropped and sized and where necessary adjusted in colour and contrast. Photoshop is an excellent way to utilise photographic material. A photograph can be imported into the program via scanning, or from a CD, or through a document sent by email. Once in Photoshop the photograph can be worked on using the various tools and the effects menu.

Untitled etching and monoprint, Colin Gale, 2007. 80 x 60 cm (32 x 24 in.). The main drawing was made in Photoshop beginning with a digital photograph. The outputted positive was then bitten onto a steel plate and inked in pink. The pink plate was printed onto a previously monoprinted background.

Screenprint construction by Lynette Farley. Screenprints using colour separations printed in seven colours. The prints were mounted onto plastic and fixed to a welded frame made from a reclaimed table.

Photoshop could have been made for printmakers. You can work in layers just as if you were making a multi-plate print. The advantage with using a computer is that you can try a colour or mark quickly. By saving your image at each stage of progression you have a catalogued history so it is always possible to go back to an earlier stage. In other words, you don't have to worry about making a mistake!

One of the most useful features of Photoshop is the ability to print out colour separations. If you examine a colour picture in a newspaper using a magnifying glass, you'll see it is made up of dots of blue (cyan), magenta, yellow and black. This is referred to as a CMYK [cyan, magenta, yellow, black] image. Photoshop can print out an image and split it into four greyscale (black and white) printouts. These can then be used to make four plates or screens which can then be printed in the traditional way. The help section explains how to do this. Select Help, printing Photoshop, then printing colour separations.

RESOLUTION

Artwork for positives can either be printed out in line form (solid areas) or as dots (halftone). Halftone is expressed as DPI (dots per inch). As an aid for comparison, newspaper images are printed at 72 DPI, while quality artworks such as postcards are printed at 300 DPI. For printmaking the following are good guides: for etching, 200 DPI; for lithography (hand-printed) and screen-printing, up to 100 DPI; and for digital prints, use 300 DPI.

This example shows how an image scanned from a newspaper can be quickly reworked using the brush tool and colour palette.

Photoshop tool palette

Rectangle/ellipse selection tools	Move tool for moving selections or layers
Polygon & freehand lasso selection tools	Magic wand tool for selection by colour
Crop tool	Slice tool
Healing brush tool	Brush tool
Clone stamp, paints with a copy of an image	History brush tool
Eraser	Gradient tool for creating colour blends
Blur tool	Dodge and burn tools for lightening & darkening
Path selection tool	Horizontal type tool
Pen tool for creating vector paths	Rectangle tool
Notes tool	Eyedropper tool, samples image colours
Hand tool, moves image within its window	Zoom tool for magnifying/ reducing views
	Current foreground & background colours
Standard mode button	Quick Mask mode button
	Screen mode buttons

The image is scanned into the computer using a flatbed scanner. Once on the screen, the image is cropped to the required composition. The paintbrush tool and a colour are selected. The brush size can be changed as needed and any colour in the spectrum can be selected.

Brushstrokes are added. Each stage is saved as city1, city2, etc. In this way you can always go back to a previous version.

The colouring is completed.

At this stage I have experimented with various effects form the pull-down Filter menu and sub-menu Artistic. This menu contains as many as 15 filters including watercolour (left) and neon glow (right), which have been used here.

'City watercolour filter' printed from an Epson inkjet printer.

PAINTER

This extremely user-friendly program mimics the marks of familiar artists' materials such as pastel, pencil and charcoal. Opening a new page on the computer desktop presents you with a toolbar giving options of pencil, rubber, water droplet, pastel and charcoal.

This is a great program for those who love mark-making!

Painter's basic brush palette. It features pencil, rubber, water droplet, chalk/pastel and charcoal.

It very quickly becomes possible to explore the mark-making possibilities within Painter.

Tronchetto and Apostoli

Tessa Holmes, 2007. Inkjet on paper, 50 x 50 cm (19½ x 19½ in.).

Untitled (Maroon and Black)

(maroon black 1, top; maroon black 2, middle; maroon black 3, bottom), Randal Cooke, 2007. Inkjet on paper, 50 x 30 cm (19½ x 12 in.).

8 Stone Lithography

LITHOGRAPHY IS TECHNICALLY REFERRED TO as a planographic process, meaning it is a print taken from a flat surface. Its invention over 200 years ago began with the use of slabs of Bavarian limestone. Stones are still used by artists today, as well as zinc plates and photosensitive aluminium plates.

Lithography relies on the fact that oil and water do not mix. A drawing is made on the stone or plate using greasy materials. The non-image areas of the stone or plate are treated with gum arabic. Once processed, the plate or stone is rolled with ink; the greasy image areas attract ink and the non-image areas hold water.

This chapter illustrates the use of stones and photoplates. I have decided not to include zinc-plate lithography due to the fact that it is becoming more difficult to find the graining machines necessary to regrain the zinc plate surface. I see stone and photoplate as the future sustainable options for lithography.

STONE LITHOGRAPHY

Stone lithography is loved by many printmakers due to its unique mark-making potential. On one surface and within a single inking it is possible to paint and draw a wide variety of marks, ranging from subtle washes to heavy, dark areas. It is also possible to prepare the stone with a grained surface on which to work – coarse, medium, fine or smooth.

Financially, stone lithography is perhaps the cheapest printmaking process, as the same stone is used over and over again by grinding its surface with carborundum. Thus a single stone can be used for decades. The stones are also very heavy: only the smallest stones should be lifted by one person on their own.

Lithographic stones originate from a single valley in Bavaria, where the limestone is particularly fine and dense. The stones are no longer quarried there; however, most studios seem to have adequate stocks to meet demand.

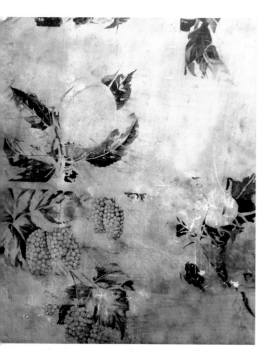

A fragment of lithographic stone, with original, early 20th-century designs possibly for jam-jars.

A lithography class with drawn stone by Anna Proctor.

In this chapter two examples are illustrated that show the use of lithographic stones. The first stone shows the range of marks and materials it is possible to draw directly onto the stone. The second stone is used to demonstrate the use of transfer paper. This technique allows the artist to make a drawing in the landscape on specially prepared paper. The drawing is then transferred to a stone in the studio. An advantage with this method is that the final image will print the right way round.

WORKING

Select a stone of appropriate size to the image to be drawn. It is possible to work right up to the edge of the stone, but printing will be easier if a margin of at least 3 cm (1 in.) is left. This allows placement of the scraper bar on the margin, ensuring that no image area is missed.

Check that the stone is flat. Use a straight edge and a strip of tissue. Pull the tissue – it should be trapped under the straight edge. If the tissue moves very easily then the stone is not flat. Avoid a stone that is dipped in the centre, as it may prove problematic during printing. A dipped stone is caused by years of improper graining causing the centre point to be lower than the edges.

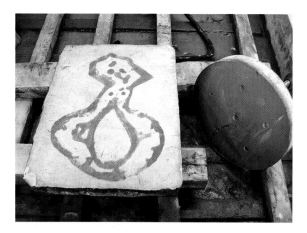

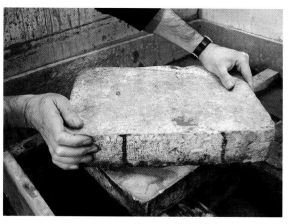

There are two ways to regrain a stone: using a cast-iron levigator or using two stones one on top of the other. Graining literally removes a layer of stone that contains the previous image. In both cases coarse carborundum (aluminium oxide 80 grit) is used with water. The levigator is spun by hand over the stone in a figure-of-eight pattern. This is the quicker of the two graining techniques and is the sensible option for larger stones.

Using one stone on top of the other is practical for small stones. It also has the advantage of regraining two stones in one go. The top stone is moved over the bottom one with carborundum between them.

LEFT Coarse carborundum with water on the stone surface prior to graining.

RIGHT Keep graining until the previous image is no longer visible. Remember that even when the image cannot be seen, grease from the image may still be present in the stone. In stone lithography the greasy drawing physically becomes part of the stone. If the grease remains, it is possible that the previous drawing will show up in your image during printing of the stone. Therefore, check for grease by rubbing liquid asphaltum into the wet surface using a clean rag. If no image shows, it is OK to proceed to the next stage.

During graining, water and carborundum must be regularly added. Pay attention to the sound of the graining. When the sound becomes smooth and dry, add fresh grit and water.

The surface is now polished using a block of snake stone (water of Ayr stone). Pay special attention to removing scratches on the surface.

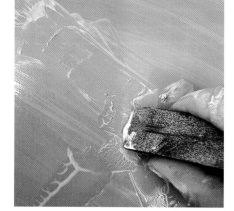

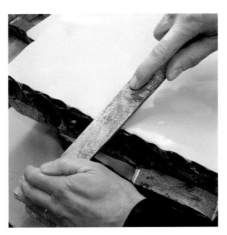

Use a lead pencil to highlight scratches. This gives an indication of how a scratch will appear if it is allowed to remain, though of course this is a lesser concern with an image that is heavily worked or vigorous in expression.

The edges are now filed to a smooth bevel. Use a coarse file that is kept only for this process (as it is used near water it will rust).

To prepare the stone to accept the greasy drawing materials you should use acetic acid (9 parts water to 1 part acid). This is referred to as counter-etching. Wet the stone with water and liberally pour on the counter-etch solution. Allow it to sit on the surface for two minutes; it will fizz gently. Then rinse the stone thoroughly with water.

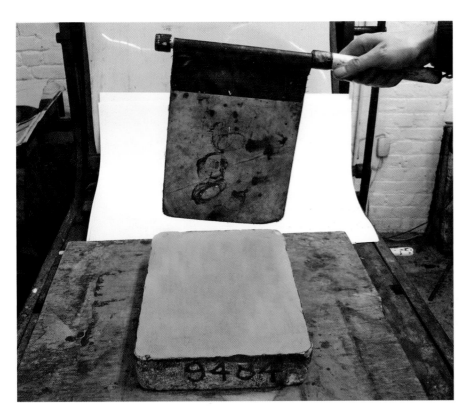

As stones are heavy and electric dryers should not be used near water, a handheld fan should be used to dry the stone.

DRAWING ON STONE

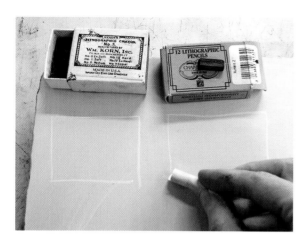

Blackboard chalk can be used to map out a basic design on the stone. This is merely an aid, as chalk is non-greasy and will not form a mark that will print.

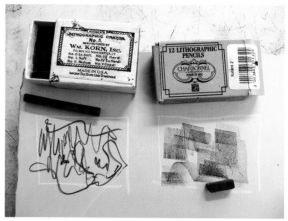

Lithographic crayons are supplied in stick form. They are graded soft to hard, plus copal (extra hard). Softer crayons deposit a heavier, more greasy mark. Use crayons at their point or on the edge for flat shaded areas.

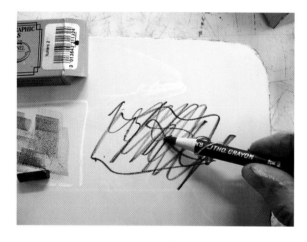

Lithographic pencils are graded in the same way as the crayons. These can be sharpened to a point using a blade.

Rubbing blocks are used for toning and smudging over large areas.

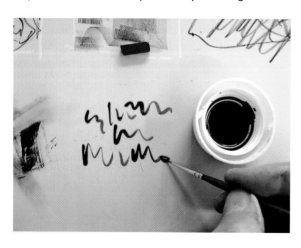

Liquid tusche is applied with a brush. This will print as a solid colour.

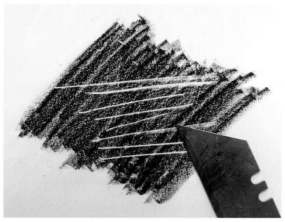

Stick tusche is dissolved in purified water. It can be used to create solid marks or can be further diluted to make washes.

A sharp blade is used as a drawing tool or to make corrections.

The finished drawing must be processed before printing (see the section below, 'Using transfer paper', for processing instructions).

USING TRANSFER PAPER

Transfer paper can be purchased from printmaking suppliers. It has a specially prepared gum surface. The transfer paper can be worked on using lithographic crayons, lithographic pencils and tusche.

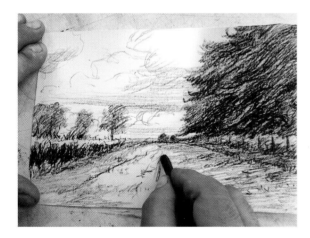

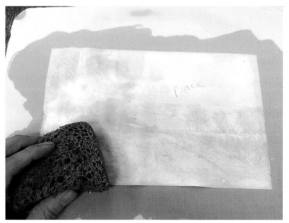

Melvyn Petterson drawing onto a sheet of transfer paper.

To transfer the image to the stone, the stone must first be counter-etched using acetic acid [see page 75]. Place the drawing face down onto the stone. Wet the back of the drawing using a clean sponge and water. The transfer paper may at first cockle slightly, but will then relax, flat onto the stone once enough moisture has penetrated through.

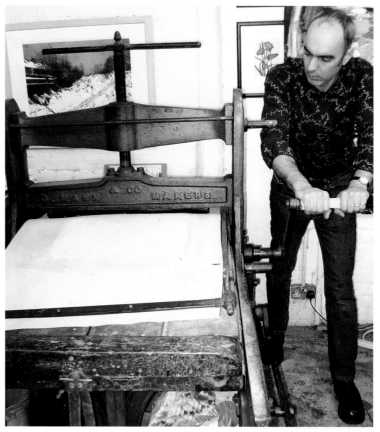

Cover the transfer with a sheet of plastic [a cut down super-market carrier will suffice], then place several sheets of smooth paper on top to act as packing. The plastic helps force the moisture through the transfer paper and prevents the packing from becoming saturated.

RIGHT Now set the pressure [see page 80] and run the stone through the press.
Lift the tympan, remove the packing and plastic and re-damp the back of the transfer paper. Again run the stone through the press.

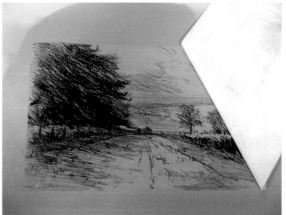

After two passes through the press, examine the progress of the transfer by carefully peeling away one corner of the transfer paper. In this case the drawing has not completely transferred to the stone, the paper is again dampened and the stone pressed.

After the third pass the drawing has been satisfactorily transferred to the stone and the backing paper is removed.

PROCESSING THE DRAWN IMAGE

ABOVE AND RIGHT **The drawn image is dusted with resin and French chalk. This process protects the image from the acidic nature of the gum/acid mix used in processing (etching) the stone. Resin is an acid resist, while the chalk prevents the smearing of the drawing materials onto the non-image areas of the stone.**

ETCHING THE STONE

Pure gum arabic solution (purchased as a liquid, typically 14 degree Baumé) is mixed with drops of nitric acid. This is called the gum etch. The gum etch ensures the greasy drawn image is securely bound to the lime-stone surface. It also chemically separates the stone's surface into greasy, image areas which attract ink and non-image areas which hold water and repel ink. Nitric acid is added to the gum arabic using a special glass-dropper bottle. **As this procedure uses pure acid, it must be handled carefully. Gloves and eye protection must be used.**

The number of drops added to the gum depends on the nature of the drawn marks on the stone. Heavily drawn parts of the image – heavy crayon or solid tusche drawing – require a stronger etch than lightly or delicately drawn areas, such as light crayon or tusche washes. For some images, a single-strength gum etch will often suffice. However, if the stone is drawn with an image containing very varied tones, it may be necessary to mix two or three strengths of gum etch in separate containers. These are applied to the stone, beginning with the weakest etch for the most delicately drawn areas, and finishing with the strongest mixture for the heaviest/darkest parts of the image.

A dropper containing nitric acid and a plastic lid containing gum-arabic solution.

All manuals on lithography contain gum etch tables. These tables give different strengths of gum etch in terms of the number of drops of nitric added to 1 oz (28 g) of gum arabic. A practical way to measure 1 oz (28 g) of gum is to use the plastic lid from a 5 litre container. Pour the gum Arabic into the lid and add the drops of nitric, then stir the mixture gently using the wooden end of a paint brush.

Carrying out an effervescence test on the margin of the stone.

STANDARD ETCH TABLE

light crayon and washes	6–12 drops	7–10 seconds effervescence (or none)
medium work	12–18 drops	5–7 seconds effervescence
heavy crayon and solvent washes	18–25 drops	2–5 seconds effervescence

Standard etch tables are intended as a guide, as every stone is unique and reacts differently. For example, grey stones, which are harder, need a stronger etch than softer yellow stones. The real guide to etching a stone lies in making effervescence tests on the margin of the stone. Mix the etch according to the standard etch table. Test it by pouring a small quantity onto the margin of the stone. The etch will react/froth after a number of seconds. If the etch reacts instantly it is too strong and should be diluted by adding pure gum arabic. When the gum etch is satisfactory, distribute it using a clean rag or sponge over the whole stone surface. Buff the gum down to a thin layer. This is very important! If the gum is lying thickly over the drawn areas it will be impossible to wash out the drawing at the next stage. Leave the gum etch to dry for at least one hour.

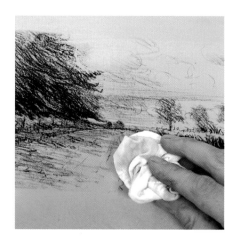

Distributing the gum etch with a clean rag.

SETTING THE PRESSURE

RIGHT The pressure must be reset for each stone, as each is different in thickness. Place five sheets of cartridge paper over the stone. Lower the tympan and slide in the press bed until the stone is at its halfway point under the scraper bar.

FAR RIGHT The pressure screw is turned sufficiently that when the pressure lever is engaged firm resistance is felt.

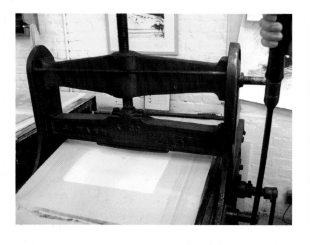

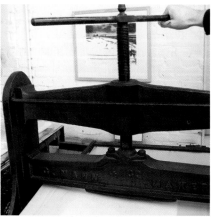

WASH OUT

The next stage is to wash out the drawing materials and replace them with ink. The ink used is non-drying proofing ink. This ink is rolled on with a leather nap roller, which has a textured surface like felt on the outside. As the ink contains no dryers it is not necessary to clean the roller after use. The non-drying black is intended as a processing ink, although it is perfectly acceptable to print an edition with it, but note that it takes longer to dry than standard litho inks.

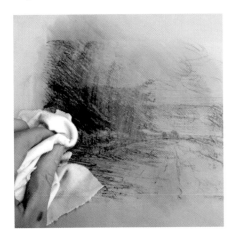

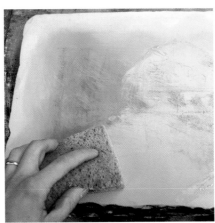

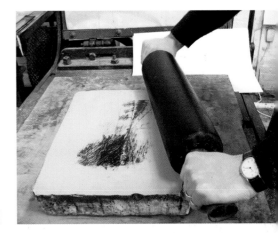

Pour on a little white spirit and begin to wash away the drawing material (remember that gum arabic is protecting the non-image areas). When all the drawing is washed out, apply a little liquid asphaltum and rub it into the image. Asphaltum strengthens the greasy image and acts as a key to the ink.

Using a sponge and water, wash off the gum arabic.

Making sure the stone is damp, begin rolling the image with ink. Take proofs onto newsprint until the image is printing strongly. The first pull will be light. The image must be built up slowly as overinking will cause the fine detail to become clogged. It usually takes between three and five inkings or printings onto newsprint for the image to become strong. The image should be black in the darkest areas.

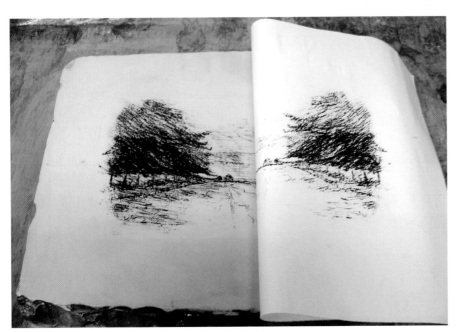

LEFT The third proof being pulled. The image is of sufficient strength to be assessed. If the image is satisfactory, then the stone is dusted with resin and French chalk and given a second gum etch as before. The second gum etch stabilises the image prior to printing the edition. The gum etch is allowed to dry for at least an hour before proceeding with the wash out. The image may now be printed using black or a colour. It is usually the case that an image requires reworking. Areas may be removed by scraping with a blade or polishing with a hone (a shaped sliver of pumice stone) dipped into water and nitric, 10:1 strength. To add drawing, the stone must be counter-etched using the 9:1 acetic-acid mix. Counter-etching removes the adsorbed gum layer.

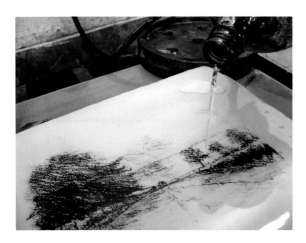

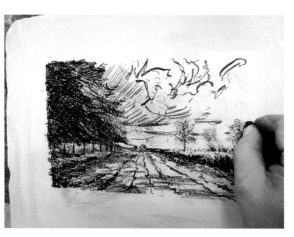

To add drawing: first it is necessary to resin and French-chalk the drawing to protect it. Then flood the image with the acetic-acid solution. Leave for a few minutes before rinsing thoroughly, then dry the stone.

The drawing is strengthened using lithographic crayons.

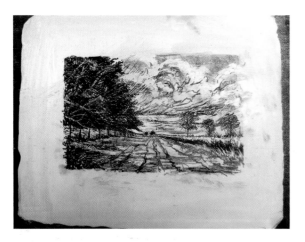

Once the drawing is finished it is again processed as before; resin and French chalk and gum etch.

The drawing is washed out and rolled with ink. Proofs are again taken on newsprint.

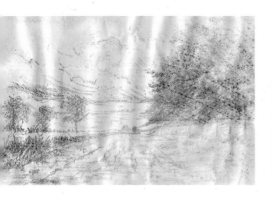

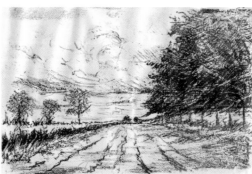

The three newsprint proofs.

The final image being pulled from the stone.

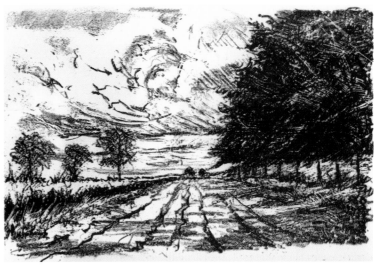

The final print on off-white 300 g Somerset paper.

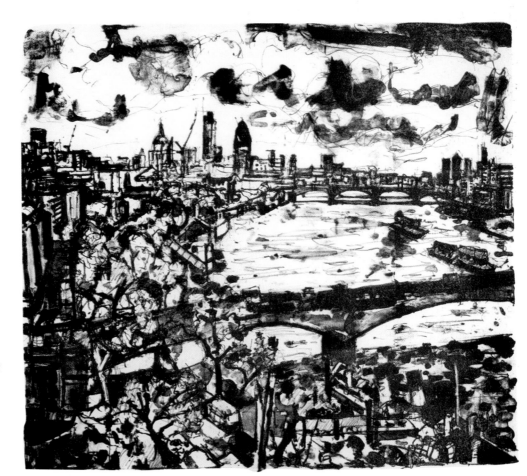

View from the Savoy Hotel

Peter Spens, 2006. Stone lithograph using crayon and tusche washes, 50 x 70 cm (19½ x 27½ in.).

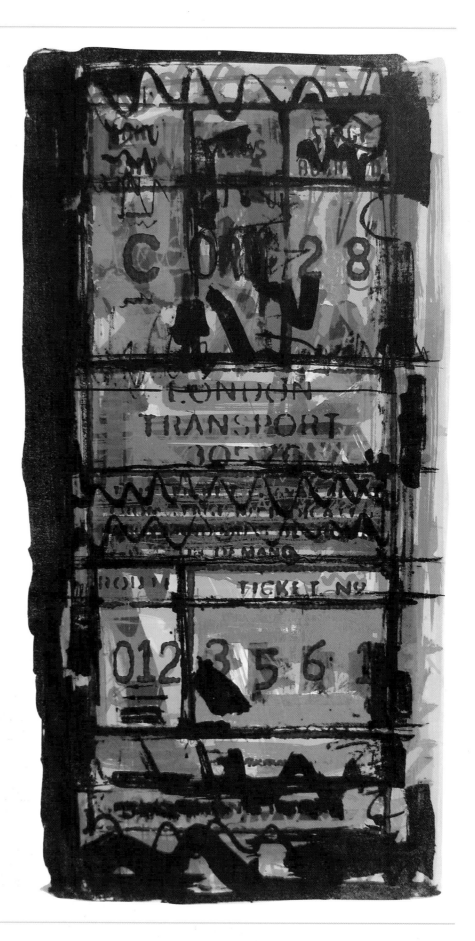

Ticket

Colin Gale. Stone lithograph in seven colours, 40 x 70 cm (16 x 27½ in.). The final plate was printed from a photolitho plate using an enlarged Routemaster bus ticket.

Untitled

Zeng, 2005. Stone lithograph, 60 x 50 cm (23½ x 19½ in.). The white areas were created by 'burning' the drawing with a strong nitric acid and water mix. The final colour uses the 'rainbow roll' technique, where two or more colours are rolled together simultaneously.

A Foreign Place

BELOW Andrew Bird. Stone lithograph on a coarsely grained (unpolished) stone, 50 x 70 cm (19½ x 27½ in.). Note that the image is drawn to the edges of the stone.

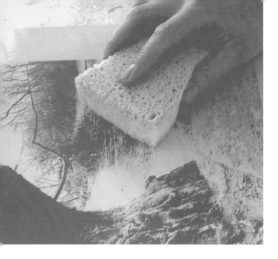

9 Photoplate Lithography

THIS TECHNIQUE USES COMMERCIAL LITHOGRAPHIC plates, which are widely available and thus very economical to purchase. For the artist-printmaker they offer possibilities for both hand-drawn work and photography-based imagery. The plates themselves are aluminium typically 0.3 mm thick and coated with a light-sensitive emulsion. The plates are exposed to a positive image in a UV lightbox.

USING PHOTOGRAPHS

The following example uses a standard colour photograph as its source. The photograph is first photocopied either as a paper copy or an acetate, though if you're using a paper copy it should be oiled with vegetable oil. This makes the paper semitransparent so that the light in the exposure unit can penetrate more easily.

The photographic source material.

The paper photocopy together with vegetable oil and a cotton-wool ball.

Rubbing the photocopy with oil.

The oiled photocopy is placed onto the glass in the exposure unit. The plate is placed emulsion side down over the photocopy.

The plate is exposed in the light box. Where the light hits the plate (the semitransparent, non-image areas), the emulsion is softened and will wash away during development. If you are not familiar with the correct exposure time it is necessary to make an exposure test strip (see page 92).

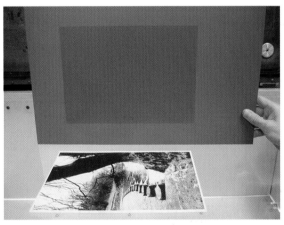

The plate after exposure. A slight trace of the image should show.

DEVELOPING

The plate is placed into the processing sink, and liquid positive developer is poured over it. The developer needs to be spread quickly over the whole surface using a soft rag or cotton wool. Gloves must be worn. The exposed areas of the plate will quickly wash away, leaving plate emulsion on the image areas.

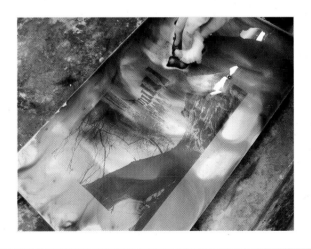

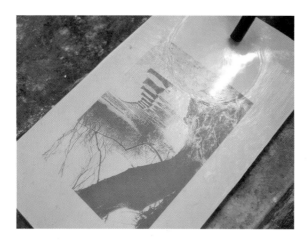

Rinse the plate with water.

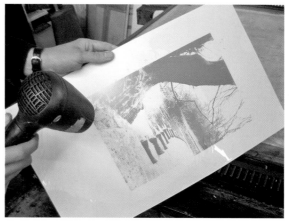

Dry the plate.

PROCESSING THE PLATE

The plate is processed with gum arabic. Synthetic gum is formulated specifically for this technique. The gum desensitises the non-image areas and makes them water-attractive or hydrophilic. The emulsion which forms the image is grease-loving and will attract ink.

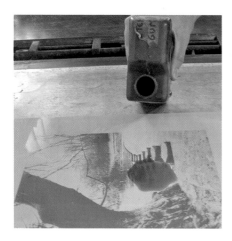

Pour a pool of gum onto the plate.

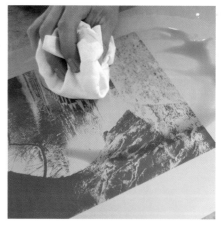

Using a clean cotton rag, spread the gum over the entire surface.

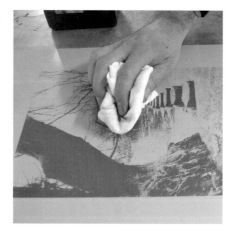

Buff the gum to a thin layer, making sure that no gum is sitting on the emulsion.

INKING

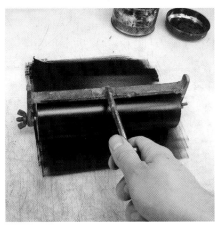

Prepare the lithographic ink – any colour may be used.

Remove the gum with a sponge and water.

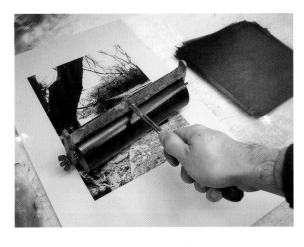
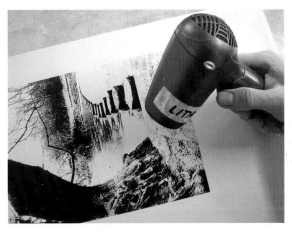

Making sure that the plate is damp (though not wet, as too much water can cause inking problems), begin to roll the image.

Dry the plate. The plate is now ready to proof onto newsprint. The image will take between three and five newsprint proofs to reach full printing strength.

TIP IF THE INK IS SLOW TO TAKE, WITH THE PLATE DAMP MIX SOME OF THE PRINTING INK WITH A LITTLE PURE TURPENTINE AND GENTLY RUB IT INTO THE IMAGE WITH A CLEAN RAG. ALLOW THE SOLUTION TO SIT FOR A MINUTE BEFORE CONTINUING WITH THE ROLL-UP.

PRINTING

If you do not have access to a litho press, these plates can be successfully printed using an etching press.

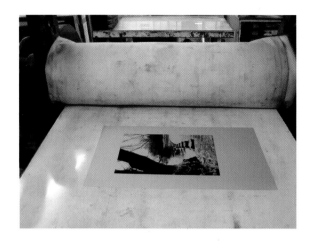

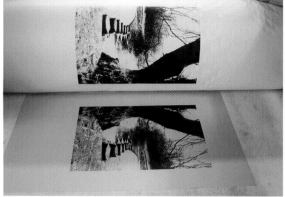

The inked plate on the bed of an etching press.

The inked plate on the bed of an etching press.

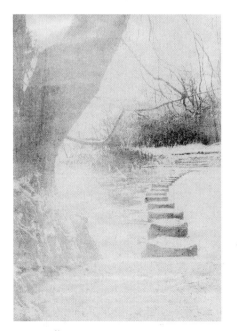

The three newsprint stages, showing typical progress in building the image to printing strength. The plate is damped with water and re-inked for each printing.

Once the image has been proofed to full strength, it may be printed onto fine paper (right).

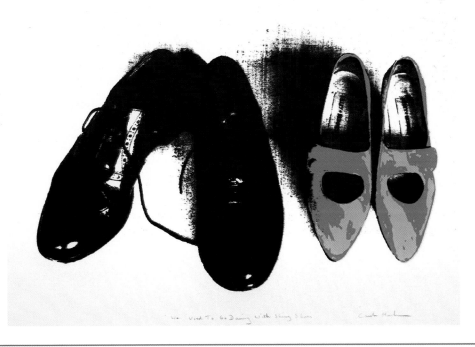

We Used to Go Dancing

Carole Hensher, 2007. Lithograph using photoplates, 76 x 56 (30 x 22 in.).

MAKING AN EXPOSURE TEST STRIP

Take an offcut of plate and place it face down over the positive. The plate is exposed in one-minute sections and developed. The developed plate can then be examined to determine the required exposure time.

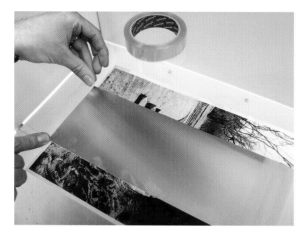

RIGHT **Tape the plate and positive to the glass so that it cannot be accidentally moved.**

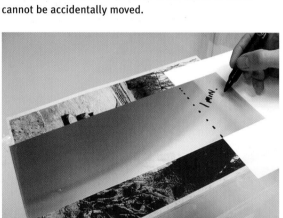

Expose the whole plate for one minute. Slide a sheet of paper between the positive and the plate. This paper blocks further light from hitting the plate. Write 'one minute' on the back of the plate with a permanent marker. Expose the plate for a further minute. Slide the blocking paper along. Continue until the final quarter of the plate has been exposed for four minutes.

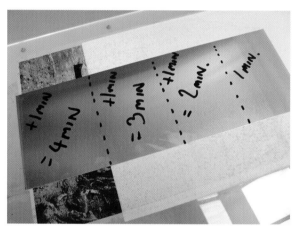

The test strip after four minutes' exposure time.

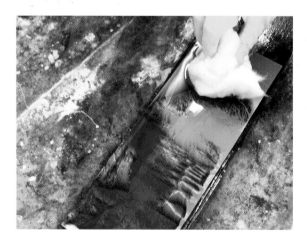

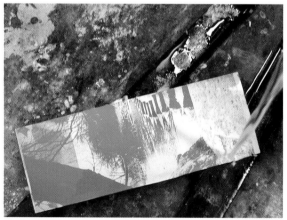

The test strip is developed and rinsed. The two-minute band was selected as the ideal exposure, giving the correct balance between the white areas and the retention of detail.

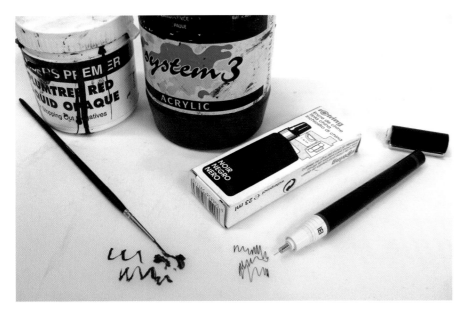

Use opaque drawing materials to draw onto semitransparent drafting film. Materials that work well include black acrylic paint, black drawing ink, liquid photo-opaque, lithographic crayons and dark pastels. The marks that you draw will be the marks that print.

HAND-DRAWN POSITIVES

This example by Tom Phillips shows how drawn marks are translated and how a colour image is built up in layers. The advantage in using transparent drafting film is that the layers, referred to as separations, can be laid over the master drawing, ensuring each layer registers accurately.

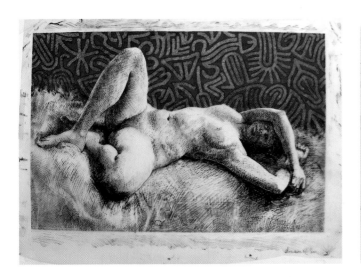

The master drawing.

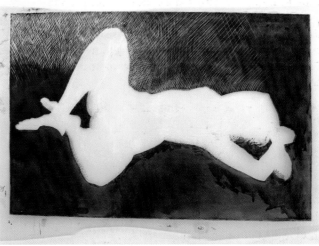

The drawn separation for the first printing in orange.

The drawn separation for the second printing of green.

The lithograph after the first two colours have been printed.

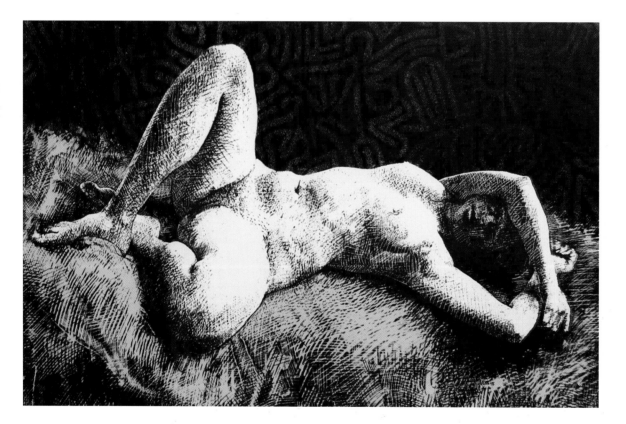

Semele

Tom Phillips, 1993. Lithograph, 56 x 76 cm
(22 x 30 in.). Separations were hand-drawn
on drafting film using ink and photo-opaque.
A scalpel was used to draw into the painted-
on photo-opaque.

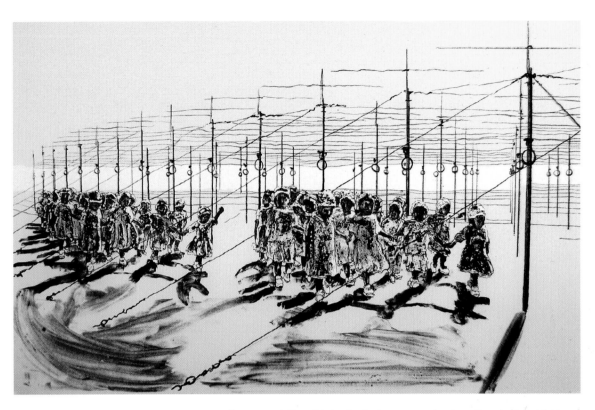

Jessie Brennan, 2008. Lithograph, 56 x 76 cm (22 x 30 in.) (detail below). The image was drawn on True Grain, a highly textured drafting film that is particularly suited to holding gradations and washes.

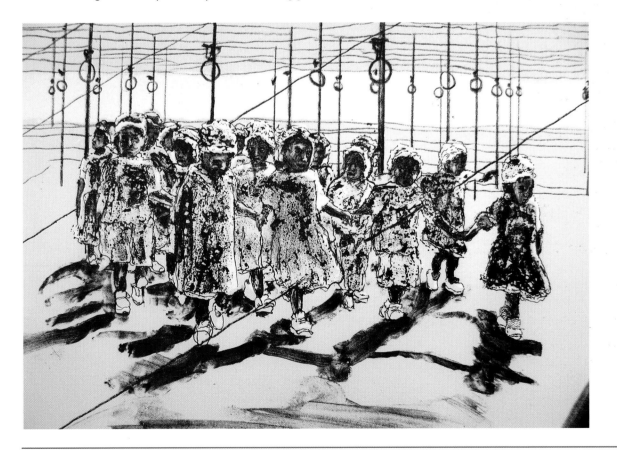

10 Screenprinting

SCREENPRINTING IS A STENCIL PROCESS. A nylon mesh is stretched across a frame made of wood or aluminum. Parts of the mesh are blocked out, but the image area remains as open mesh. Ink is pushed through the open mesh using a plastic blade called a squeegee, onto paper or other material below. Screen mesh comes in various grades. For water-based printing it is recommended that you use 120T mesh (120 threads per cm, with 'T' meaning standard thread diameter).

The image is built up by printing in layers, with a new stencil being cut or drawn for each layer. The simplest way to make a stencil is by cutting shapes from paper. The paper stencil is taped to the back of the screen and ink can then pass through the open, cut areas.

More advanced screen prints are made by using photostencils. These stencils consist of a light-sensitive emulsion that is coated directly onto the screen mesh. The emulsion is then exposed to positive artwork. The image areas are

Clapham Junction

Ray Gale, 2008. Screenprint using hand-cut paper stencils and one photostencil for the final printing of the line work, 50 x 40 cm (20 x 16 in.).

washed away with water, leaving open areas of mesh, through which ink can pass. With photostencils it is possible to print detail that would be too difficult to cut by hand using a paper stencil.

INKS

It is rare now to find a communal studio that uses oil-based inks. Health and safety issues have persuaded most studios and certainly all educational institutions to switch to water-based inks.

Water-based inks come in three types:
1. a clear printing medium or base mixed with acrylic paint;
2. a clear printing medium or base mixed with pigment concentrate and;
3. ready-mixed individual colours.

For the beginner I would recommend the first system. The materials are more commonly available – standard artist's acrylic paints of any brand are used. The ink is easy to mix, handle and store.

Acrylic printing medium and a tube of acrylic paint. Empty jam-jars make good mixing containers. It is easy to judge whether the colour is mixed thoroughly, and any leftover ink can be stored by screwing on the jar lid. Mix the paint 50:50 with the base medium. To increase the opacity of the colour, the paint/base mix can be pushed to a maximum ratio of 75:25.

USING PAPER STENCILS

The most basic screenprinting set-up consists of a wooden screen hinged onto a baseboard. This is a simple but effective system and is great when space is at a premium. The screen and baseboard are placed on a tabletop and can be stored away vertically when not in use.

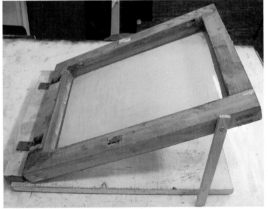

Check that the screen mesh is clean, i.e. there are no blocked areas. Hold the screen up to a window (far left) and examine the mesh. If the mesh is blocked with dried-in ink or stencil filler, it will need cleaning, in which case place the screen in a washout sink and pour a household cream cleaner onto the screen mesh. Rub the cleaner in with a sponge or stiff plastic cleaning brush. Allow the screen to sit for several minutes. Then blast the screen using a high-pressure water sprayer (left).

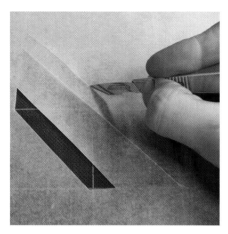

Prepare the screen for use by taping the inside edges with plastic parcel tape. The tape is placed equally across the mesh and the frame, to ensure that the right angle is fully covered. This prevents ink from becoming trapped between the frame and mesh.

A readily available paper-stencil material is greaseproof/baking paper. It is inexpensive and can be purchased on a roll from any supermarket. The paper is semitransparent and can be used in the same way as tracing paper, with an image placed underneath from which you can trace.

The stencil is cut using a scalpel or craft knife. If you don't have a cutting mat then use a wad of newspaper to cut on. Cut away the areas you want to print.

LEFT The stencil paper may be torn to obtain an irregular edge.

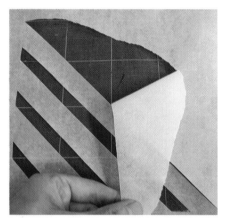

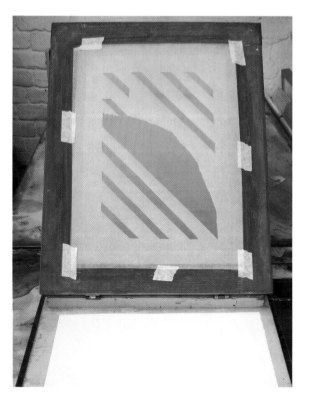

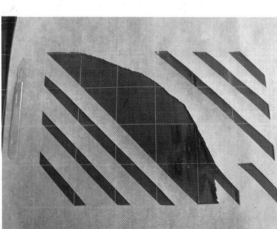

The cut stencil.

The stencil taped to the underside of the screen ready for printing.

The paper is registered to the baseboard using card tabs. Registration is important, as each layer of ink must print in the same place on each sheet of paper. Three registration tabs are needed, two on the corner and one on the leading edge. Make the tabs with card and masking tape or pre-prepare card tabs with double-sided sticky tape.

PRINTING

Before you start printing, make sure that all the printing paper is ready and have a bucket of water and a sponge handy for cleaning up.

Pour the mixed ink along the top edge of the screen. Using the squeegee at an angle of 45 degrees, pull the ink firmly towards you. Pull the first print onto scrap paper to ensure the mesh is printing as intended.

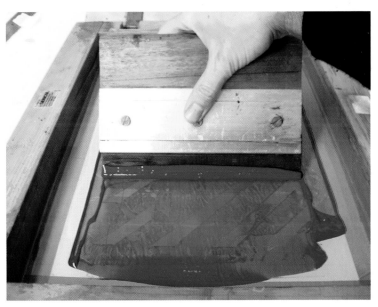

For the printing of the second sheet, the ink is flooded back with the screen raised. This fills the mesh with ink in preparation for the next pull. Individual sheets are then pulled up to the predetermined edition number. Always allow extra sheets for wastage or prints that go wrong. The sheets are then placed individually in a drying rack.

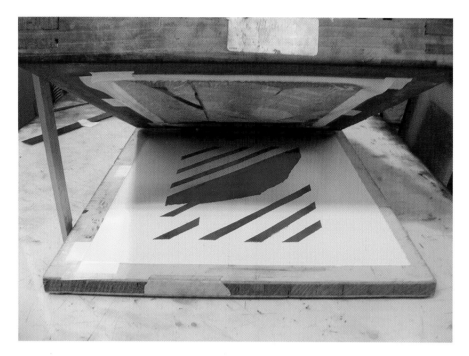

The raised screen showing the first pull.

CLEANING UP

It is important to clean up promptly after the last paper is printed. If ink is allowed to dry on the screen and equipment, it may prove very stubborn and difficult to remove.

Scoop up any excess ink using a plastic palette knife (metal may damage the mesh). Excess ink can be stored in an airtight container and used at a later date.

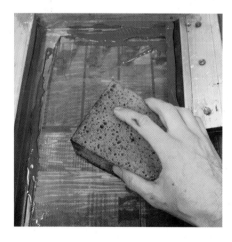

Remove and discard the paper stencil. Place newspaper under the screen. With a sponge and water clean the majority of ink from the screen and squeegee.

Spray on Mr Muscle cleaner and continue with the sponge and water until all traces of ink have been removed.

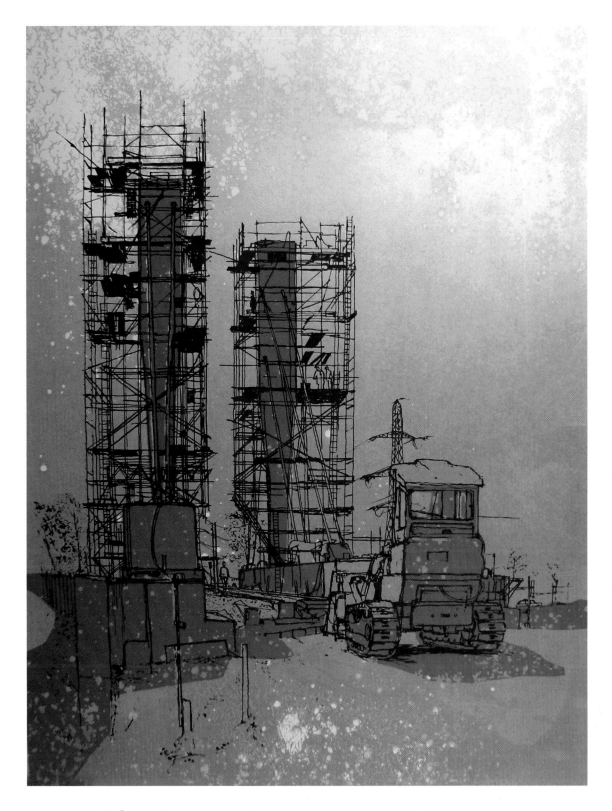

Lyne Bridge Construction

Ray Gale, 1978. Screen print using hand-cut stencils and one photostencil, 36 x 46 cm (14 x 18 in.).
Sprinkling French chalk onto the paper prior to printing created the texture in the sky.

PHOTOSTENCIL SCREENPRINTING

The use of photostencils enables the accurate printing of hand-drawn marks and photographic images. The photostencil is by its nature more stable than a paper stencil, which would disintegrate over the course of a longer print run.

This example uses a painted positive – black acrylic on drafting film.

Black acrylic paint, applied using a brush and a piece of card onto drafting film.

Setting up for direct-stencil screen-coating. A clean screen (degreased using cotton wool and methylated spirit); an aluminum coating trough with fitted plastic ends; screen emulsion; and a plastic blade for scraping off any excess emulsion.

The aluminum coating trough is filled with the liquid photo-emulsion.

The screen is coated on the back (the side that will be in contact with the paper). The trough is pressed firmly onto the mesh and tipped so that the emulsion is touching the mesh. This procedure is carried out in a dimly lit room without daylight, so as not to expose the emulsion to UV light.

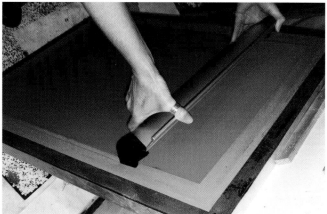

In one continuous motion, with firm pressure, the trough is pulled up the screen, leaving the mesh evenly coated with emulsion. Note the strip of wood screwed to the wall, wedging the screen to prevent it from moving during coating. The screen is now left to dry gently in the dark with the help of an electric fan heater.

EXPOSING THE SCREEN

Once dry to the touch the screen is ready to expose. A UV exposure unit with a vacuum hood is used. The screen is placed over the positive that will form the stencil. During exposure the emulsion is hardened, except where the black drawn areas of the positive prevent the UV light from hitting the emulsion. The drawn areas remain unexposed and soft, and will wash away with water, leaving the open-mesh areas of the screen.

The screen exposing, showing the vacuum forming over the screen giving a good contact between the drawing and the emulsion. The exposure time is measured in light units. This time will vary according to the nature of the positive and the make of exposure unit. For example, a positive on clear acetate will need a shorter exposure time than a positive on paper such as a photocopy.

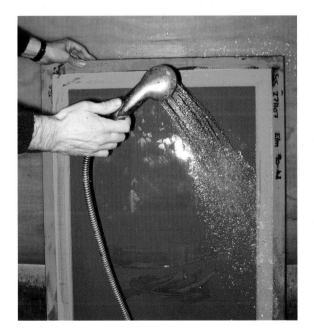

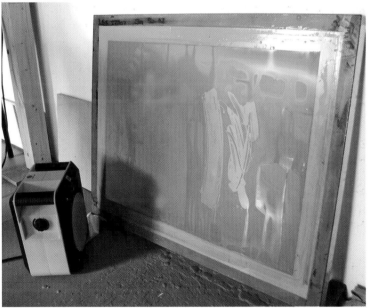

The screen is now developed by gently spraying it with warm water. The unexposed area (the drawing) will wash away.

The screen is now dried using an electric fan heater.

PRINTING

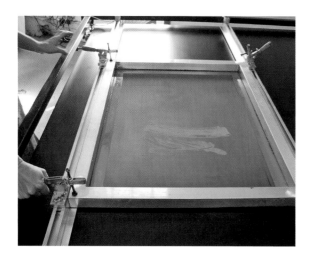

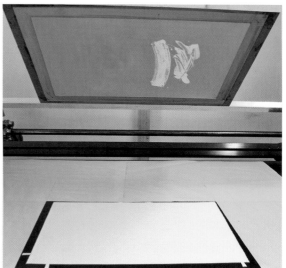

The use of a vacuum printing bed has many advantages over the hinged screen baseboard. The screen is firmly clamped in place into a frame that is counterbalanced, enabling the screen to be lifted easily up and down. The vacuum, which sucks air through hundreds of holes in the bed, keeps the paper fixed down so that there is no chance of the paper sticking to the screen when the screen is lifted after each sheet is printed.

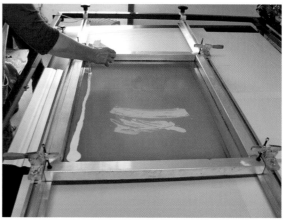

The paper is positioned and registered using three tabs of card. The bed shown here is large, so newsprint sheets are laid down to cover the vacuum holes not covered by the printing paper.

The ink is poured onto the screen.

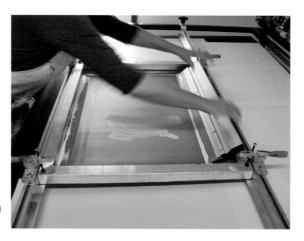

The screen is lifted slightly and the mesh is flooded with the ink.

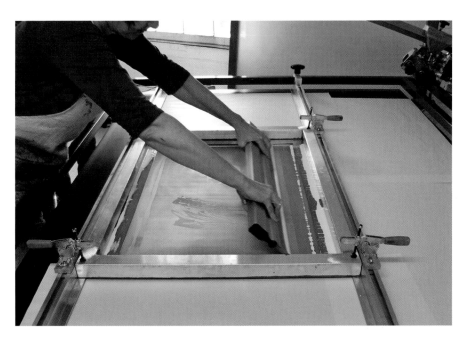

The first print is pulled.

The print on plain paper.

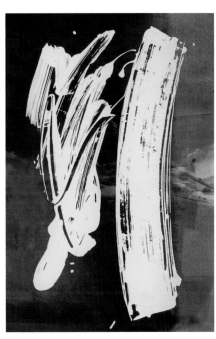

The print on a prepared colour background.

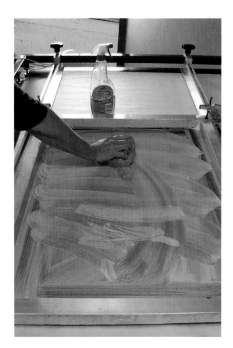

After printing, excess ink is scooped away using a plastic blade. The screen and squeegee are cleaned using a sponge and water together with a professional-grade household cleaner such as Mr Muscle.

STRIPPING THE EMULSION

When the stencil is no longer needed, the emulsion is removed and the screen can then be used for the next stencil layer. The screen is placed into a wash-out booth. Liquid stencil stripper is applied to both sides of the mesh.

Leave the screen to soak for a few minutes before blasting the emulsion away with a high-power jet wash.

A high-pressure water cleaner.

The Red Shoes

Anita Klein, 2002. Screenprint with woodblock printed using oil-based inks (edition size 75), (image size) 61 x 46 cm (24 x 18 in.), (paper size) 77.5 x 62 cm (30½ x 24½ in.). Printed and published by Advanced Graphics, London.

TEXTILE PRINTING

A screenprinting medium/base is available that is specially formulated for printing onto textiles. The base is mixed with acrylic paint or pigment concentrate. Generally, the screen mesh used for textile printing is coarser (typically 43T) than that used for paper due to the textured nature of the material to be printed.

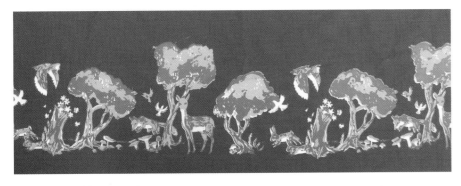

Printed run of cotton by Jane McGuinness. The colours were reduction-printed using a photostencil, i.e. the stencil area was reduced after each printing by partially painting out the previously printed colour using liquid screen filler.

ABOVE **Stopping out of the screen mesh prior to printing the second colour layer.**

RIGHT **The printed material was made up into a pinafore-style dress by Jessica Corlett.**

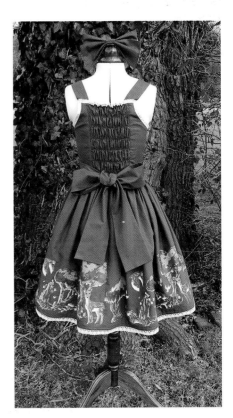

IMAGE PLANNING

An image is built up in layers, using a separate stencil for each layer. Depending on the size of the image being printed, it may be possible to put several or even all the stencils onto one screen, saving much preparation time and cost in materials.

This example by Linas Tranas, a student at the Maidstone School of Art, shows the four colour layers used to print the complete image, exposed together on one screen.

Screen with four stencils. The printing order went clockwise from the bottom left: yellow, green, red and black. For each printing, the three stencils not used were blocked out underneath with a paper mask.

The stencil for the black printing was exposed from a computer inkjet printout on paper. The other three positives, one for each colour, were hand painted onto drafting film.

11 Relief Printing

RELIEF PRINTING IS PRINTING FROM A SURFACE. Unwanted areas are cut away and the raised surface that is left is inked. Relief prints can be printed by hand-burnishing or by using a press. Traditionally, relief prints were made by engraving boxwood blocks. These blocks were then set with wooden or metal type to form illustrated pages of text. Boxwood is not commonly used now, due to its expense and size restrictions. The main surfaces for relief printing are now manmade products such as plywood, MDF (medium-density fibreboard) and hardboard, which are all cheap and easily available. Moreover, in recent years new materials such as engraving vinyls and resins have also become available to printmakers.

Untitled

Tony McCormack, 1995. Relief print, 56 x 76 cm (22 x 30 in.). There has always been a strong tradition of artists printing from found surfaces. With this unique approach Tony has inked steel tin lids, offsetting one on top of another.

A large-scale relief print in progress using plywood, by Colin Gale. Plywood has a very characteristic grain which splinters when cut, producing interesting textures. Chalk has been used to rub over the surface to give an indication of how the marks will appear when eventually inked.

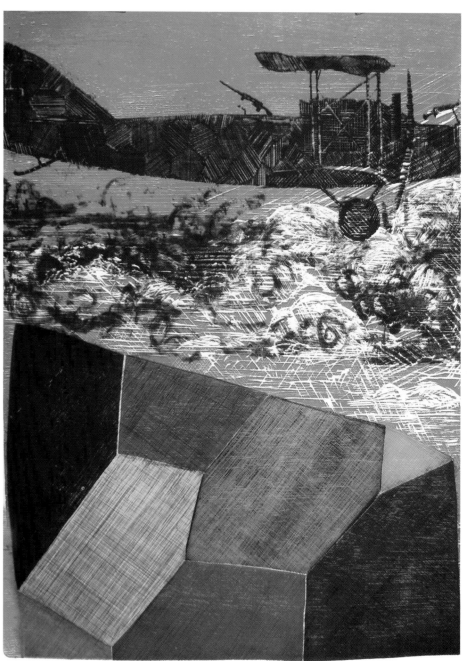

Sagitarius Rising

Colin Gale, 2008. Woodcut, etching and lithograph. Size 80 x 112 cm.

An assortment of relief printing blocks/ surfaces. From back to front – plywood, lino, vinyl, engraving resin, cherry wood, boxwood.

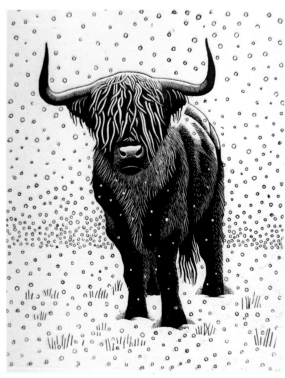

Winter Encounter

Philip Solly, 2007. Engraving using resin, 15 x 20 cm (6 x 8 in.).

LINOCUT

Linocut is probably the most commonly used relief-printing process. It is a technique of immense popularity due both to its directness and its capacity for producing bold, colourful images. In linocut, areas are removed using cutting tools, and the surface that is left is inked up and printed from.

Once common as a floor covering (especially on ships, hence the common name 'battle-ship lino'), linoleum can be obtained from craft shops or printmaking suppliers in short rolls or in various standard sizes. The lino itself is smooth and grain-free. It is commonly brown or grey in colour with a cloth backing, and is approximately 4 mm thick.

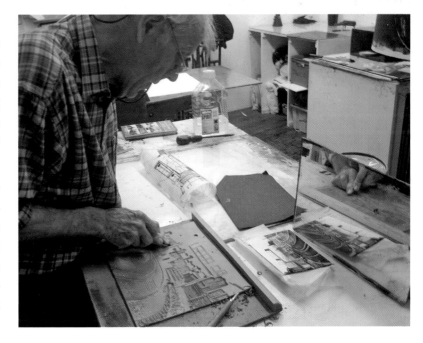

Ray Gale cutting a lino block. Note the use of a bench hook for cutting and a mirror to reverse the photographic source material.

Lino tools are metal gouges which vary in shape from V-shaped cutters for fine detail to flat, U-shaped gouges used for removing wide areas of the linoleum surface. The most cost-effective cutting tool for the beginner consists of a kit comprising a selection of interchangeable blades that slot into a plastic handle or holder.

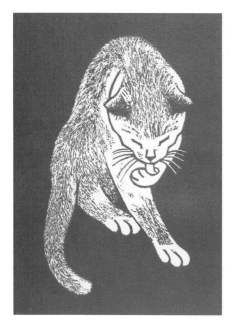
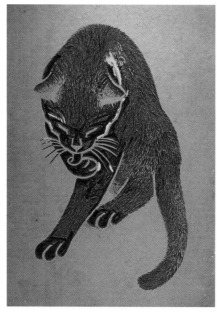

Cat Washing

Philip Solly, 2007. Linocut, 12 x 16 cm (4¾ x 6¼ in.). The print in grey together with the lino block.

Multicolour lino prints made from a single block is called the reduction method. Firstly, the highlights are cut away and all the sheets for the edition are printed with the first colour (usually the lightest tone). Then more lino is cut away and the second colour is printed. Cutting and printing continues until only the final details, usually the darkest parts of the image, remain.

For more complicated designs or those where very separate and distinct colour areas are needed, two or more blocks of the same size can be used. To work this way it is essential to have a key tracing of the main image areas that can then be transferred onto each block.

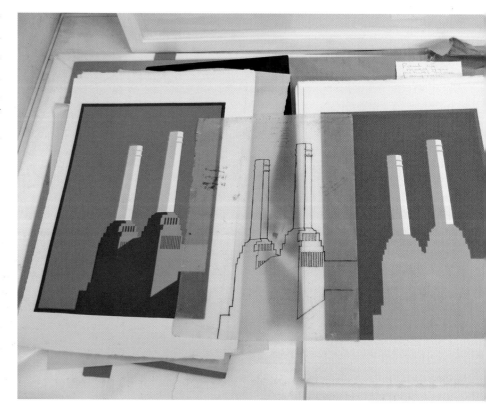

Lino prints in progress, two variations. Note the key tracing.
Photo courtesy of Paul Catherall.

In terms of printing, lino is extremely versatile. It can be hand-printed by burnishing or printed using a press. Most types of printing presses can be adjusted to print linocuts.

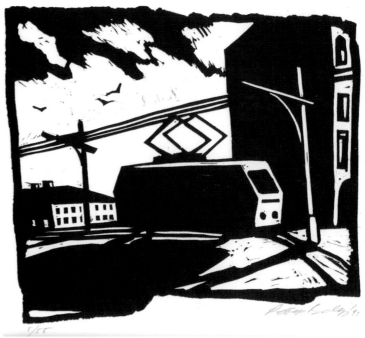

Hand-burnishing a shaped piece of lino using the back of a spoon.

Untitled

Peter Belyi, 2001. Linocut, 19 x 17 cm (7½ x 6¾ in.).

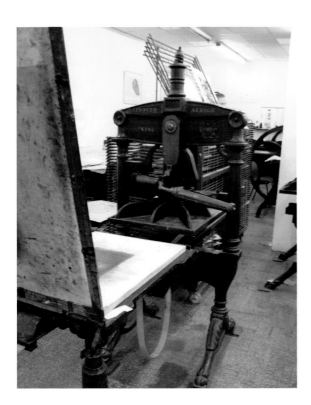

A Victorian Albion press at Maidstone College of Art used by the students for lino printing.

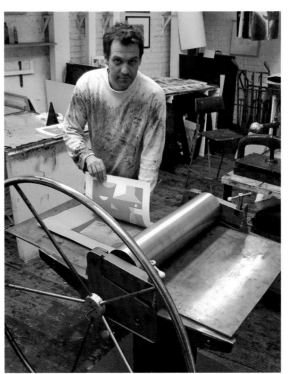

Artist Paul Catherall printing using a top-sprung-roller etching press. Note that blankets are not required.

THE REDUCTION METHOD

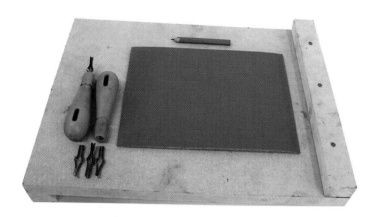

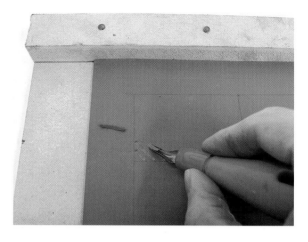

A homemade bench-hook, grey linoleum, cutting tools and a pencil for marking out the image.

After the basic design has been marked out on the lino, the areas that are to remain white (the paper colour) are cut away.

REGISTRATION

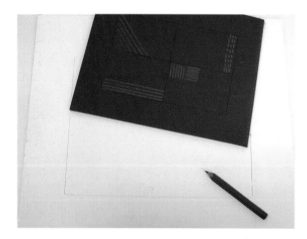

It is important that images are printed squarely and centrally onto each sheet. The simplest way to achieve this is to cut or tear the edition paper to the same size. Take one sheet, the backing sheet, and position the lino block in the centre. Draw around the edges of the block with a pencil. Each time the block is inked you should position it again within the pencil marks. The printing sheet is then laid on top, edge to edge with the backing sheet.

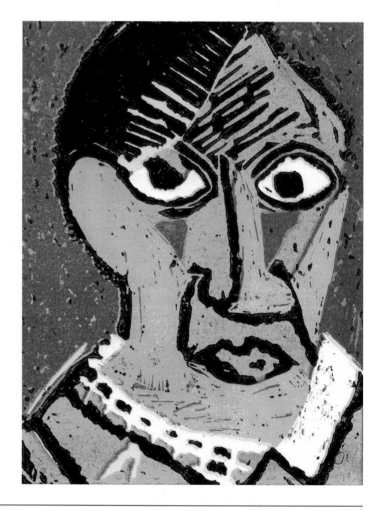

RIGHT **A reduction lino print in five colours, made in one day by a secondary-school student, 15 x 20 cm (6 x 8 in.).**

PRINTING

The first colour is pulled, roller-width, onto the glass using a scraper or push knife.

Roll the colour into an even slab. Pay attention to the sound of the ink as it is rolled. The ink should sound 'swishy'; if it sounds 'sticky' then the ink is too thick, and some should be removed using the push knife.

The yellow is rolled onto the lino.

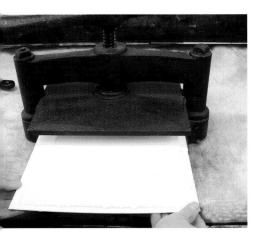

The inked block is placed on the backing sheet, and printing paper is placed on top. A second sheet is added over this to act as packing in the press. The paper 'sandwich' is carefully placed into a nipping press.

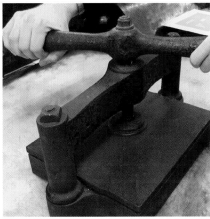

The pressure is applied by turning the screw threads. It is necessary to use quite a lot of physical force when printing using this kind of press.

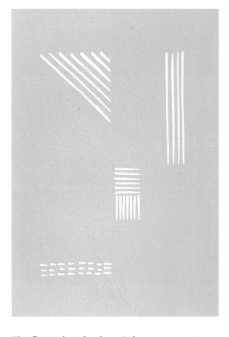

The first printed colour. It is necessary to re-ink the block for each sheet of paper.

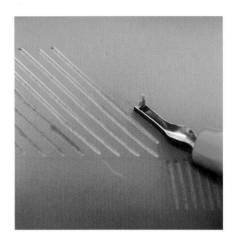

Once all the sheets for the edition have been printed, the lino block is cleaned of ink. All the areas that are to remain yellow are now cut away.

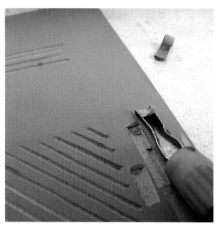

A broad scooping blade is used to remove larger areas of the lino.

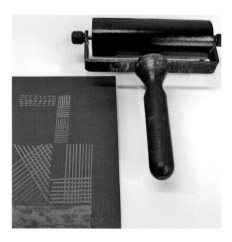

The block is now inked with the second colour, the red. The block is registered by printing it face down onto the yellow. In this way it is easy to see where the inked block needs to be placed.

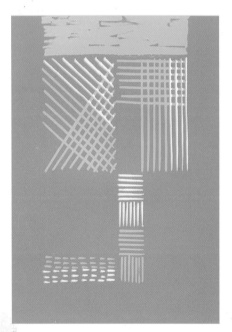

The image after the red printing.

The third and final cut, prior to blue printing.

The final print, *Composition in yellow, red and blue.*

THE DEVELOPMENT OF AN IMAGE

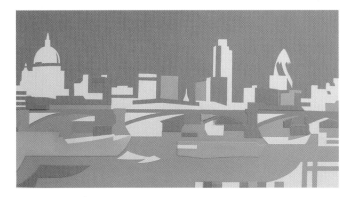

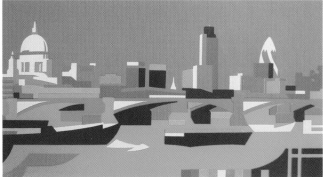

Cityscape

Paul Catherall, 2008. Linocut, 90 x 49 cm (35½ x 19¼ in.).

Paul Catherall printing *Cityscape*.

DRYING

A ball drying rack is a practical way to dry lino prints. This type of drying rack is suspended from the ceiling, and therefore is great for saving space. It is also considerably cheaper than a floor-standing rack. Prints may take several days to dry, depending on the number of colour layers and the atmospheric conditions.

Tate Burgundy

Paul Catherall, 2003. Linocut, 43 x 90 cm (17 x 35½ in.).

Sunbird Jane Bristowe, 2007. 30 x 30 cm (12 x 12 in.).

Green Tea Paula Cox, 2004. Linocut, 30 x 30 cm (12 x 12 in.).

WOODCUT

In woodcut, not surprisingly, unwanted areas of wood are cut away. The remaining surface is rolled with ink using a roller. The ink on the surface is transferred to paper with downward pressure by hand using a burnishing tool or a printing press. The choice of wood that can be cut and printed is wide, and includes DIY products, found objects such as driftwood, and prepared pieces specifically sourced for printmaking.

The surfaces of different woods affect the characteristics of the final print in different ways. For example, plywood has a very pronounced grain which tends to splinter when cut, and thus would not be a good option if a fine result is required. However, plywood gives fascinating results on a large scale. Medium-density fibreboard (MDF) and hardboard have smooth surfaces and are both readily available and relatively cheap. For smaller, finer work, it is recommended that you purchase blocks from a good printmaking supplier.

MAKING A BENCH HOOK

A bench hook is a device which hooks onto a working desk and supports the block during the carving/making stage. It is both a practical item and a health-and-safety aid.

A bench hook can be made in a few minutes and at very little cost, if not free (the wood used in this example was discarded offcuts obtained for nothing from a local woodworker). The only tools needed are a saw and a hammer and nails. You will need a flat piece of board such as MDF at least half an inch thick, and two strips of wood.

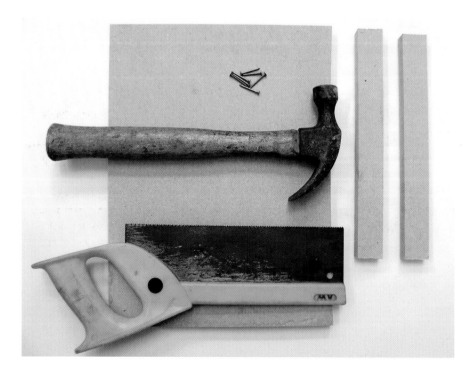

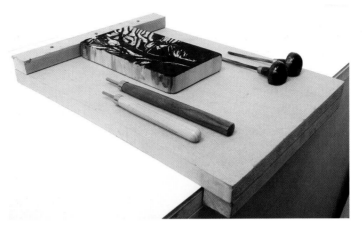

Cut the two strips to the width of the board. Nail the first strip to edge of the board, then turn the board over and nail the second strip to the opposite parallel edge.

The bench hook in position with block and tools.

THE WOODCUT

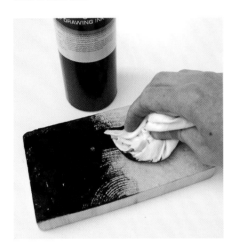

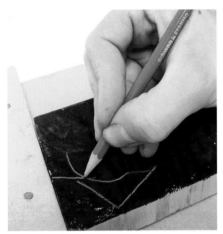

FAR LEFT **Firstly, rub black drawing ink over the surface of the block. This will help during cutting. The cut marks will show in clear contrast against the black surface that will eventually be inked.**

LEFT **The basic design is drawn using a pencil.**

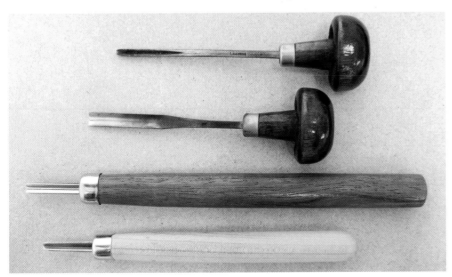

Tools for woodcut come in varying blade widths. The blade ends are shaped – U-shape for cutting large areas and V-shape for the details. Traditional Japanese tools have long straight handles, while the western-style tools have a mushroom-shaped handle that fits in the palm of your hand. It is essential that tools are kept sharp by using a smooth sharpening stone with a drop of oil.

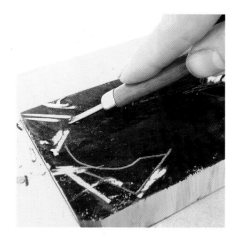

FAR LEFT **Larger areas are removed using a U-shaped gouge. When cutting, always make strokes away from the body, keeping the non-cutting hand behind the tool at all times. For large-scale woodblocks, you should use curved wood chisels, tapping them with a wooden hammer.**

LEFT **Use a V-shaped tool for the more detailed work.**

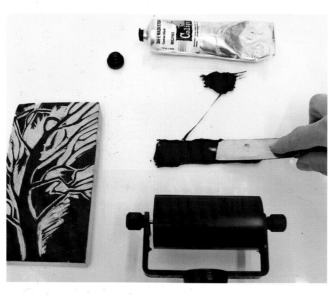

ABOVE, LEFT AND RIGHT **Ink is spread onto the inking glass using a push knife. The ink is rolled into an even layer on the glass and applied to the surface of the block.**

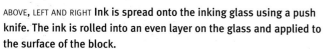

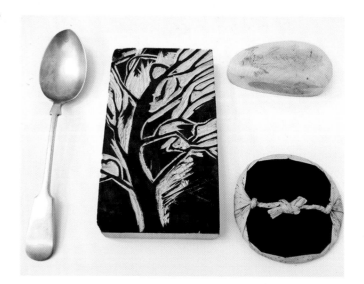

The cut block shown with three options for hand-burnishing: a large spoon, a mouse-shaped wood and a traditional Japanese disk baren.

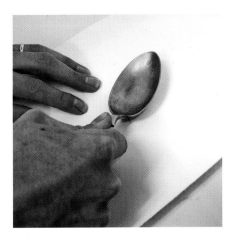

Paper is placed over the inked block. The paper is firmly burnished using the spoon to transfer the ink to the paper.

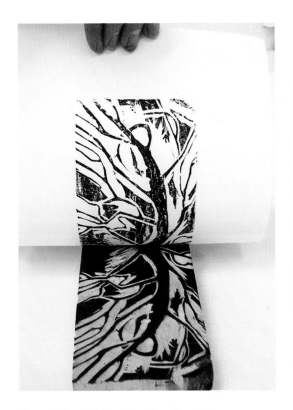

The print is carefully pulled from the block.

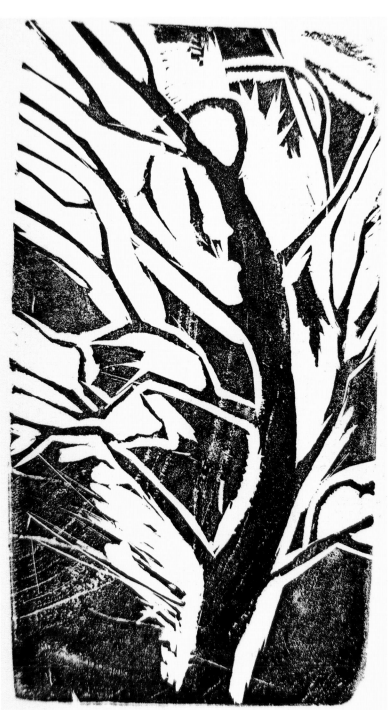

The block must be re-inked for each print.

12 Relief Printing with Stamps and Blocks

RELIEF-PRINTING BLOCKS that were once used commercially can be purchased from antiques markets and online auctions such as eBay. Look out for wooden-type, lead-type, etched and hand-cut blocks. Watch out in particular for complete sets of alphabet blocks. All these items are sought-after objects by people who want to hang them on their walls at home. As a printmaker, I take great pleasure in collecting them. They are fun to print with and are a great way to introduce children to relief-printing.

Metal line blocks used for printing trade catalogues, along with the resulting prints, which were hand-burnished using a metal spoon.

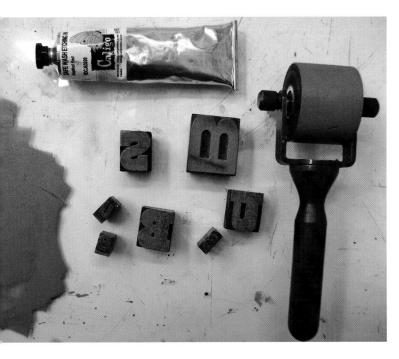

Water-washable oil-based ink used to ink wooden-type blocks.

George creating *Bus*.

A hand-cut hardwood block intended to be repeat-printed to build up a border design.

RUBBER STAMPS

A simple and inexpensive way to make relief stamps is by using pencil erasers. They are easy to make and can be printed onto almost any surface.

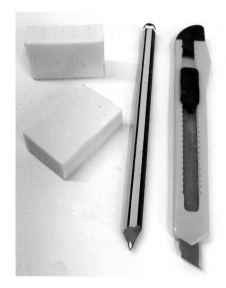

Erasers, a pencil for marking out and a craft knife.

Mark out the rubbers using a pencil. Bear in mind that this is direct printing, so the design must be cut as a mirror image.

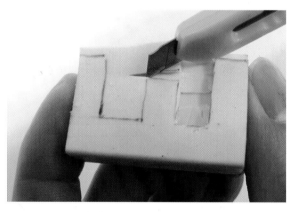

The design is then cut. Cut away the areas that are not to be printed.

The surface is then rolled with ink.

The stamp is pressed firmly onto paper.

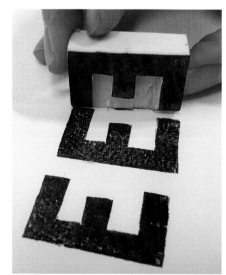

13 Monoprinting

MONOPRINTING IS A WAY OF PRODUCING expressive one-off images utilising the strengths of printmaking together with the spontaneity of painting and drawing. The technique offers the opportunity to create marks varying from subtle washes to areas of bold vibrant colour. It suits artists who like to work freely and instinctively.

A variety of surfaces may be used to monoprint from, such as acrylic sheet, metal plates or even greaseproof/baking paper.

MONOPRINTING WITHOUT A PRESS

The greaseproof paper plate is a quick and simple way to explore the directness of monoprinting without the need for a press.

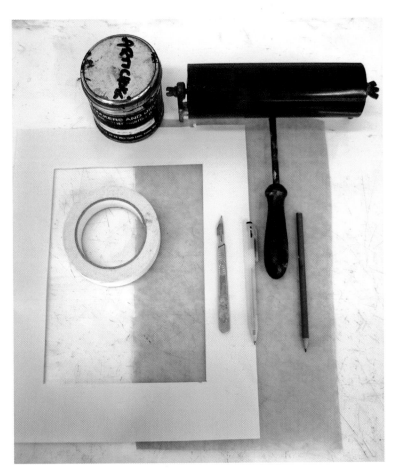

All that is needed is greaseproof paper/baking paper, ink and a roller, masking tape, thin paper cut to form a mask, and a simple drawing implement such as a pencil or a biro.

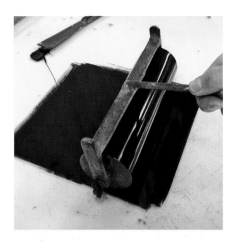

The ink is prepared on glass before it is rolled onto the greaseproof paper sheet.

The paper mask is placed and taped over the inked baking paper. The mask ensures clean margins on the final print. The inked baking paper is then placed ink side down over a sheet of printing paper.

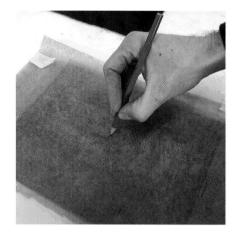

Drawing on the back of the inked baking paper transfers the ink onto the printing paper. Anything that creates pressure, such as your fingernail, will produce a mark.

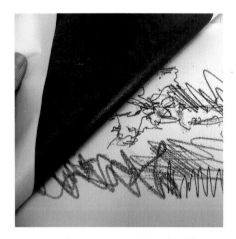

The inked sheet is peeled back to check the progress of the marks.

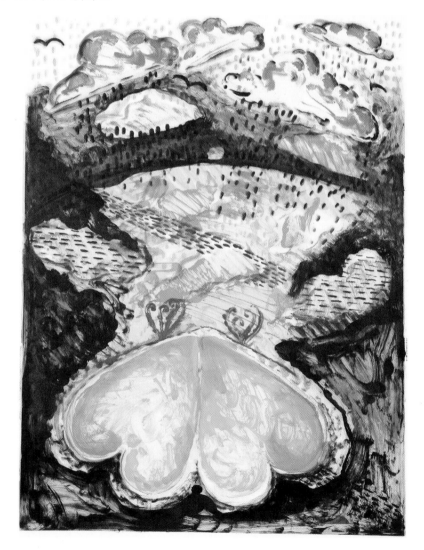

Untitled

Anna Park, 2007. Monoprint, 56 x 76 cm (22 x 30 in.).

MONOPRINTING USING A PRESS

In this example, grained polyester sheet is used. This material is a good option, as the surface has a random grain or tooth which holds the ink very well. Being transparent means that a basic image may be drawn on the back of the sheet as a guide, using a permanent marker.

Monoprints are usually built up in several layers. Each layer is run through the press and the plate is reworked each time. In this fashion complex layers of transparent colours can be built up.

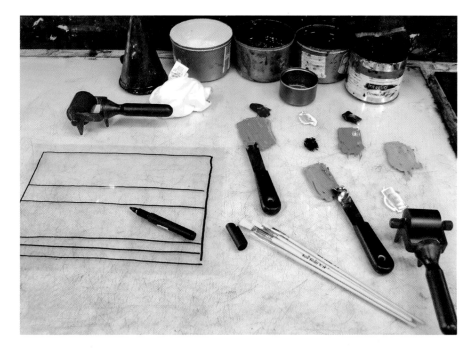

The colour palette is mixed and the polyester sheet is marked up indicating the basic image areas to be inked. Rollers, brushes and a rag with solvent are selected as drawing implements.

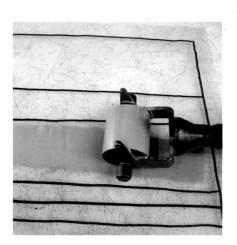

The first two colours are rolled on.

The wooden brush end is used to draw into the rolled areas.

The rag is dipped into a little solvent and used to remove areas of ink.

Ink is brushed on. It is usually necessary to thin the ink slightly with solvent.

The side of the roller is used selectively.

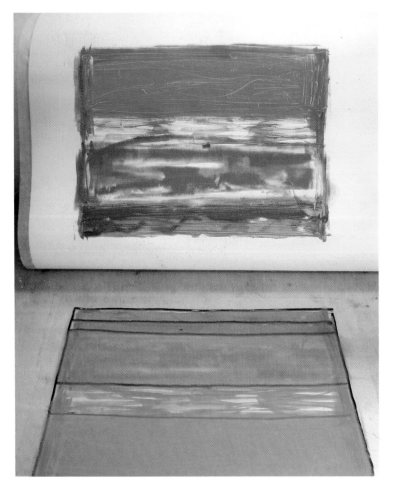

The inked plate is run through the etching press onto dampened paper. Dry paper may be used, but damping the paper will pull more detail from the plate.

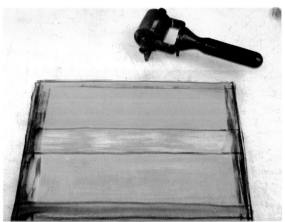

The plate is now reworked by rolling on transparent colours.

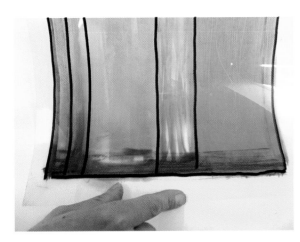

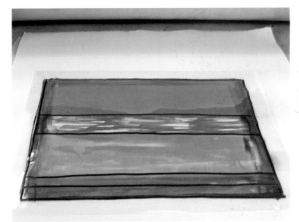

The plate is ready for the second printing. It is registered face down onto the printing paper. The first pull will have left an embossed plate mark in the paper; the plate is simply lined up using this embossing as a guide.

The plate is registered over the paper prior to being run through the press for the second time.

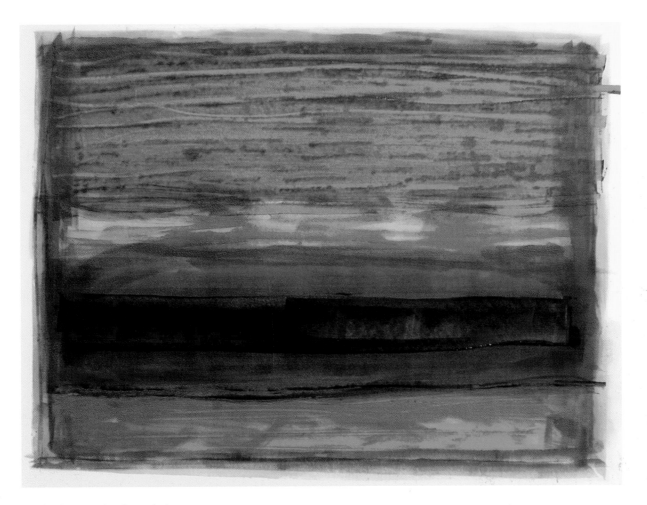

The final image after four printings.

Megan Fishpool working on the large-scale monoprint
New World III, 2007. 1 x 1 m (39 x 39 in.).

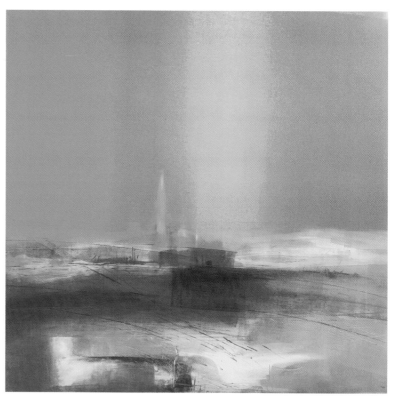

New World III

Monoprint by a student at Sutton
Grammar. 56 x 37 cm (22 x 14½ in.).

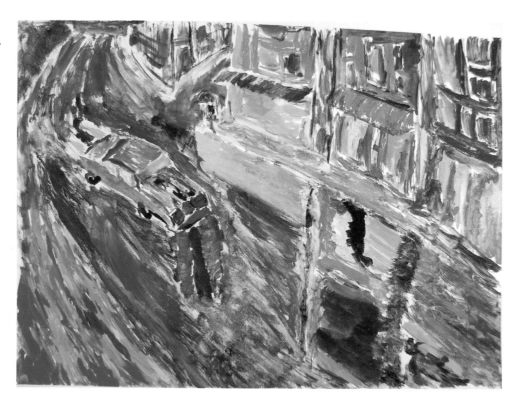

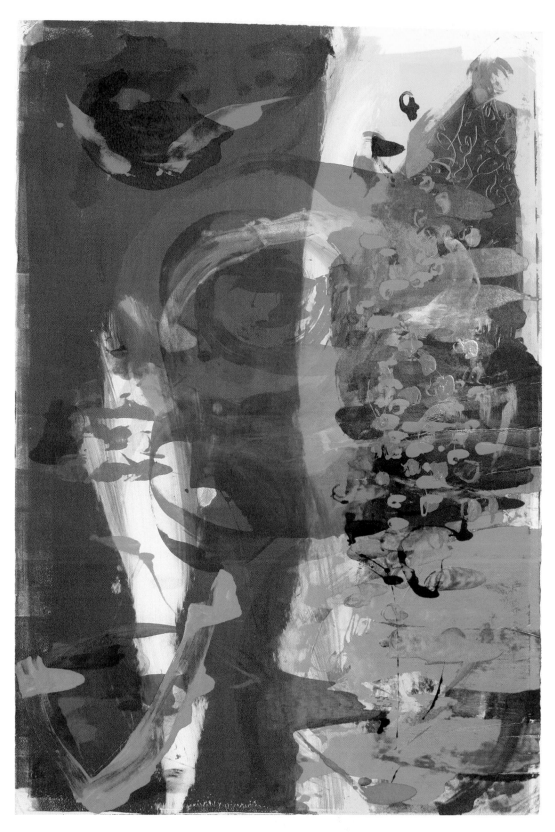

Abstract Flower Study Helen Clark, 2007. Monoprint 76 x 112 cm (30 x 44 in.).

MONOPRINTING USING WATER-SOLUBLE CRAYONS

This example shows the application of water-soluble drawing materials. Again, the method is direct and approachable as the materials used will be familiar to any artist. The technique involves no chemicals or solvents.

Grained polyester is the perfect plate for monoprinting with water-soluble pencils and crayons. The grain grips the drawing material in a similar way to textured paper.

Always use quality drawing materials as they offer the best results in terms of colour quality; and use them thinly, as thick layers have a tendency to pull up the paper fibres during printing.

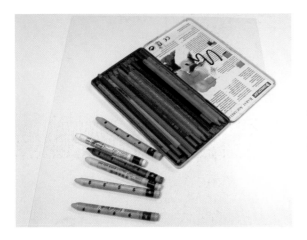

A selection of water-soluble crayons and pencils.

The main image areas are defined, and pencils are used to build up colour blocks.

The drawing proceeds with bolder marks created using the red crayon.

RIGHT This monoprinting method requires the use of a press. In this example an etching press set for normal intaglio printing is used. The paper is soaked in the usual fashion.

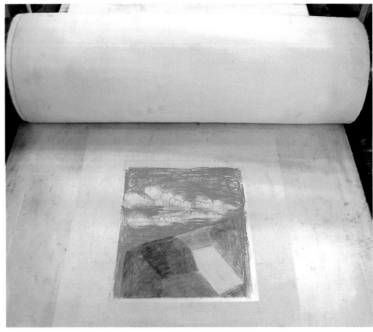

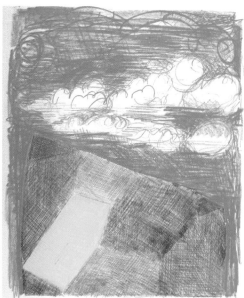

The printing paper being pulled from the polyester plate. The final print.

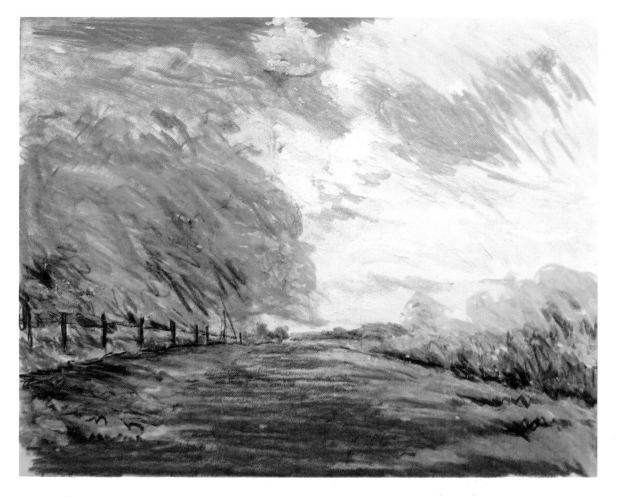

Untitled Melvyn Petterson, 2008. Mono crayon, 40 x 30 cm (16 x 12 in.).

14 Cards and Books

THE ADVANTAGE OF PRINTMAKING OVER PAINTING AND DRAWING is its multiplicity. Prints can be in many places at one time – galleries and art fairs make this possible – to communicate an artistic idea and vision. One of the best ways of sharing an image that is instantly tangible, as the items are original and bear the touch of the artist, is to make cards or books.

Artist's books and cards have a rich heritage. From the first illuminated manuscripts to the artist's books made by independent artists today, the beauty of the book or card as an object in its own right, matters as much as the information or message it conveys. For this reason, items such as handmade cards are cherished and kept by the receiver. A handmade card is an expression of the generosity of artistic spirit being shared freely.

The following are works by friends and colleagues. As a printmaker I am always taken aback when I realise just how much dedication and hard work it takes to produce such items.

Christmas cards printed from lino blocks, David Hackman.

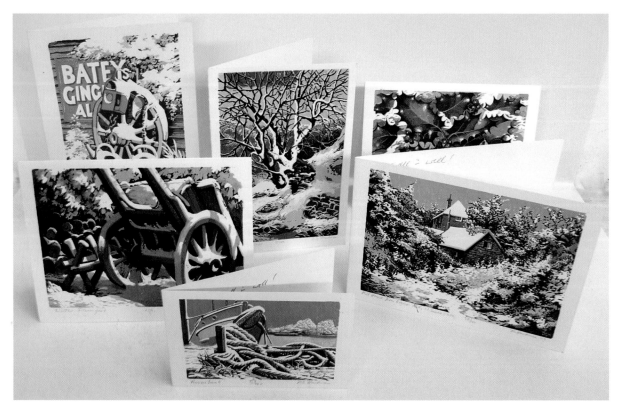

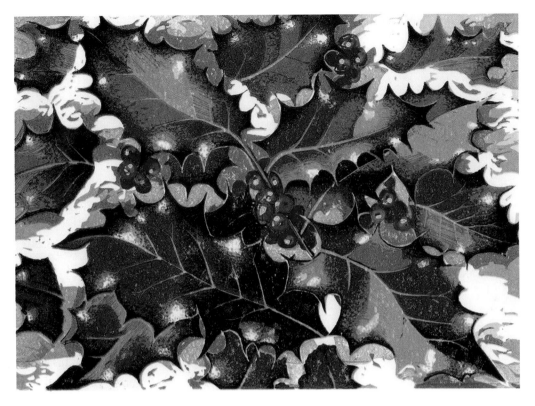

Winter Holly

David Hackman. Linocut, edition of 100.

BELOW **Greetings cards by Ray Gale. Screenprints using hand-cut paper stencils plus photostencil line work from pen and ink on drafting film.**

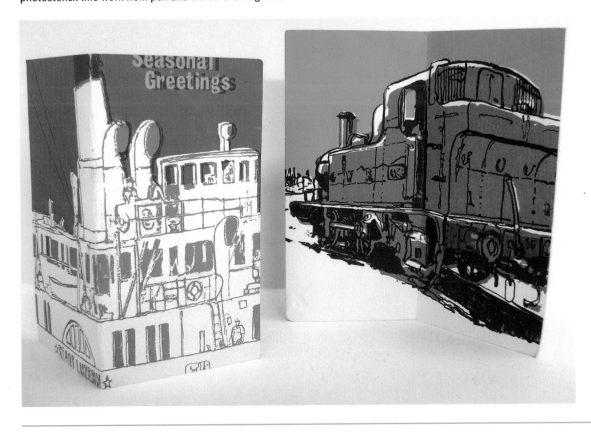

Megan Fishpool,
Christmas cards
printed from etched
copperplates.

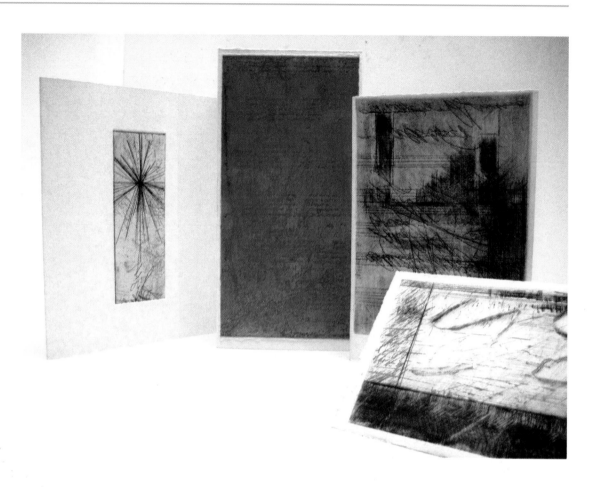

Love Match

Afsoon Hayley. Matchboxes using etching.

What's on your cover?

Sophie Herxheimer.

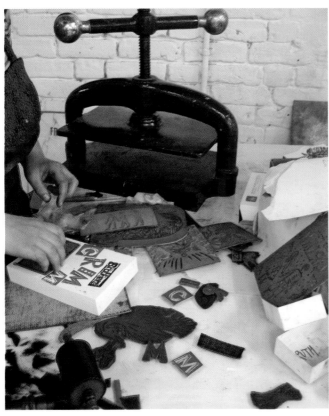

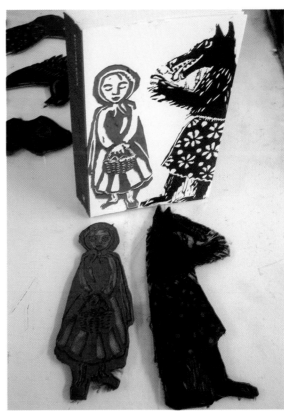

Penguin Books, Brothers Grimm. These books were supplied with blank covers inviting artists to decorate or illustrate the fronts. Sophie used linocut printed with a nipping press.

Tea at Tiffany's

Tiffany Powell. Hand-bound book. Text printed in screenprint, illustrated with etchings. This book of favourite recipes, which features a unique spine, was hand-printed in an edition of 50. The binding is simple, string threaded through holes made with an office hole-puncher. *Tea at Tiffany's* was marketed by Liberty of London and, needless to say, leapt off the shelf!

Artist's books by Myung-Sook Chae, Korea. Hand-bound etchings and lithographs.

Close-up showing the intricate hand-sewn binding, referred to as the pamphlet stitch.

MAKING A SIMPLE BOOK

This example shows how to quickly construct a simple book. It uses strips
of offcut printmaking paper and tapestry thread.

You will need: embroidery thread and
needles; a wine cork; paper offcuts; a
straight edge; scissors.

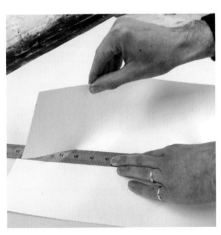

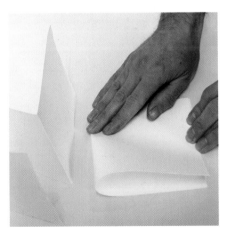

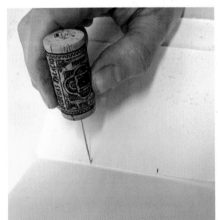

The sheets that are to form the pages are
hand-torn to the same size using a steel
rule. A cover or fly-sheet is also torn and
folded. This should be 2–3 mm larger all
round than the pages.

The pages are then folded.

Mark out a template as a guide to where to
punch the holes. Two holes are punched in
each page and the cover. To make a hole
punch, simply push the end of an embroi-
dery needle into a wine cork. The needle is
pushed through all the pages and the cover
individually, using the template as a guide.

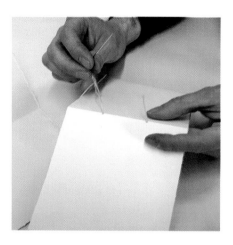

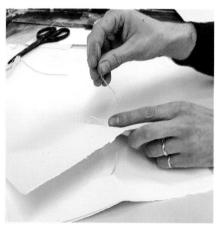

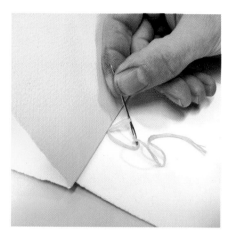

Now thread the pages (not the cover) with the embroidery cotton. Tie a double knot in the end of the thread and make the first pass from the back of the pages (the knot will be hidden when the cover is added).

Now attach the cover sheet.

Pull the thread tight and knot close to the join.

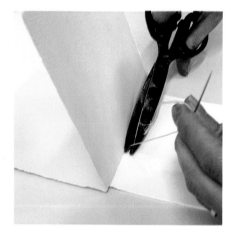

Cut the excess using scissors.

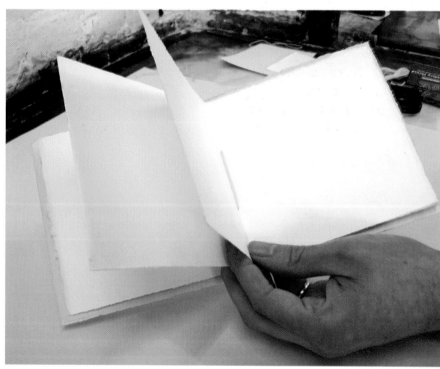

The final book template.

15 Working in the Landscape

ALTHOUGH PRINTMAKING IS MAINLY a studio-based activity, that does not mean the original plate drawing should be restricted to the studio environment.

Images that are drawn from observation always seem to have a freshness and life often lacking in work that is produced in the studio from source material such as photographs or sketches. Plates can be taken into the landscape and used just like sketchbooks. The images shown in this chapter were all drawn on the spot by the artist. In most cases the artist is not perturbed by the fact that the resulting print will appear as a mirror image and hence topographically incorrect. The point of the exercise is to catch the essence and atmosphere of the moment.

If you do need a topographically correct image, then a good approach is to set up a mirror on a sketching easel. The subject can then be viewed and drawn from the mirror. Once printed the reversed image will be a correct view of the subject. The use of lithographic transfer paper is helpful, as the image drawn after transfer to the stone will print as originally drawn.

Rachel Lindsay-Clark sketching a view of Coldharbour Lane in Brixton, London onto lithographic transfer paper.

The completed drawing transferred to stone. See the chapter on stone lithography for notes on this process.

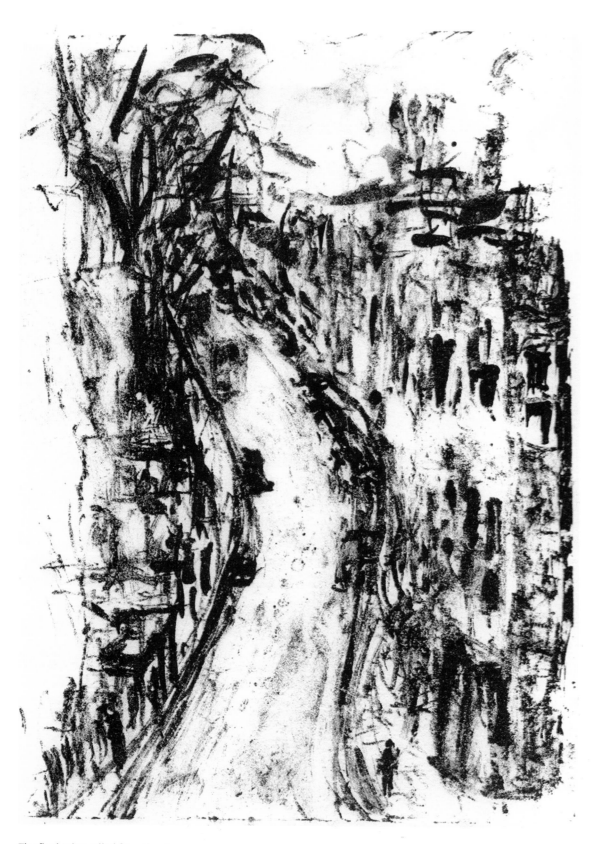

The final print pulled from the stone.

Perhaps the most straightforward of printmaking processes for working outside is drypoint – all you need is the plate and a drypoint needle!

View from Tate Modern

RIGHT **Rachel Lindsey-Clark, 2006. Drypoint on zinc, 14 x 18 cm (5½ x 7 in.).**

Bridge, Newcastle

BELOW **Melvyn Petterson, 1988. Drypoint on aluminium, 16 x 12 cm (6¼ x 4¾ in.).**

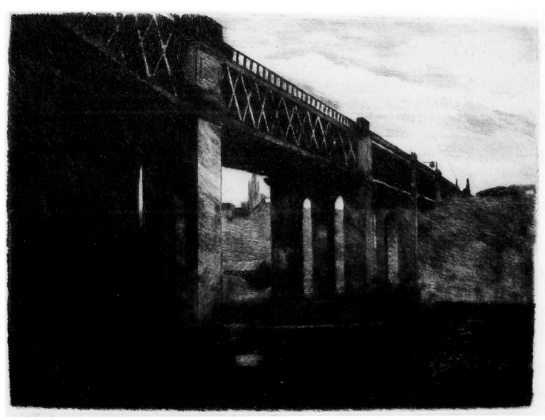

WORKING WITH HARD GROUND

Metal plates with prepared, smoked hard grounds can be easily transported, wrapped in sheets of newspaper. The plates can then be etched when you return to the studio. This is also a good way to use up those long strips of offcut plate, which inevitably accumulate but are too good to throw away.

Degrease the metal strip and lay a hard ground. Smoke the plate. Then, using a ruler and an etching tool, mark up the plate into assorted shapes and sizes. Guillotine the strips, wrap them in newspaper and secure with masking tape.

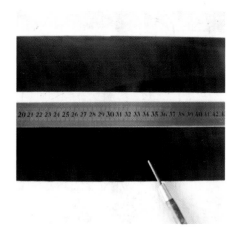

Marking out grounded and smoked strips of zinc.

The guillotined strips in assorted sizes from 6 x 4 cm (2 x 1 to 12 x 8 cm (4¾ x 3 in.).

The plates wrapped in newspaper.

Etchings by Steve White made whilst on holiday in Marrakesh in 2007.

A crayon-and-tusche drawing of London's St Pancras Station on lithographic transfer paper by Rachel Lindsey-Clark.

16 Displaying and Storing Prints

THE END RESULT, after all the hard physical and mental effort, should be to display the print to its best advantage and to let it be seen by others. Hopefully, this will result in sales!

The most practical way to do this is to hold an exhibition with a group of like-minded printmakers. Broadly speaking, galleries and events such as art fairs fall into two camps: those that charge an upfront fee, where the artist or group keeps the revenue for sales; and those that take a commission, typically 50%, on sales.

Open exhibitions where a small handling fee is charged can be another way of gaining exposure, though of course the work may not be selected. Prominent examples include the Royal Academy Summer Exhibition and the annual Originals exhibition at The Mall Galleries, both in London.

Originals 2008 at the Mall Galleries, London.

The Internet is becoming an increasingly good way of showing and selling prints. Public confidence in buying online is growing at a fast pace. Many artists now have their own website, as web-building costs have become very affordable.

At this point the subject of pricing should be discussed. The second most common question I am asked (the first is 'How long in the acid?') is 'What price should I charge for this print?' Selling price takes into account factors such as the size of the piece, the complexity of the image and the perceived standing of the artist in the art world. All these can be rationally quantified. What I always recommend is consistency in price across the entire market. To explain my line of thinking: the Internet is fast becoming the first port of call for the general public when buying goods. In a few seconds an artist can be 'Googled'. If an artist is selling through a gallery, that gallery will have a retail-selling price including a commission (typically 50%). If the same artist is selling work on a personal website for 50% less, this can lead to a problem. Anyone would be upset to buy an object only to discover the same object is available at half the cost. It is therefore important that prices for the same piece are consistent whether sold through the gallery or through your own website.

PRESENTATION

A good frame will show a print at its best. Framing can be very expensive so it needs to be right. Framers will have many different mouldings, which can be finished in many different ways – black, white, coloured, natural, etc. It can be confusing. My advice is to keep things simple as the frame should not compete for attention with the image.

Frame samples, showing from left: black stain, clear wax, silver, lime wax.

The most common selections for framing prints are wooden square-section profiles finished in either lime wax [white], stained black or clear-waxed. A good bespoke framer will have samples against which you can hold a print to judge what suits it best.

For conservation reasons a print in a frame must always be kept apart from the glass, as condensation may occur, causing mould to form. There are two framing styles that achieve this aim: a card mount or a box frame. Which to choose is again an aesthetic decision. If the appearance of the paper is an important part of the print 'as an object' then a box frame may well suit.

For experimental or three-dimensional prints it is possible to have made-to-measure frames constructed from Perspex.

A box frame. A wooden fillet separates the glass from the print.

Mick Davies, 2008. A constructed work using foam board, etching and watercolour, framed in a Perspex box.

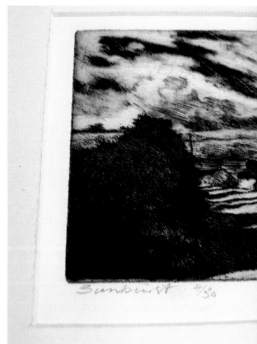

A mounted etching. The mount card should be acid-free.

DISPLAYING PRINTS

Prints can be displayed in floor-standing print browsers. Back the print with mount board and cover using thin acetate (the type that florists use). This is a good way to show plenty of work in a small space and is very popular with the art-buying public, as the works can be taken away at the time of purchase.

STORING PRINTS

Perhaps the best way to store prints is in a plans chest. Usually constructed from wood with six or eight drawers, they are designed specifically for storing paper flat. As well as being practical for storing paper, they provide a clean worktop space for examining work.

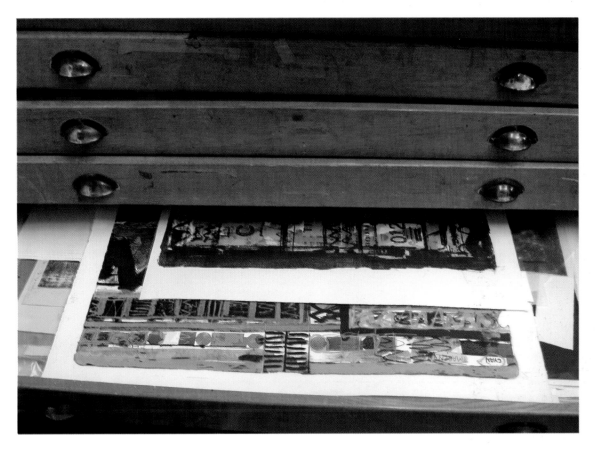

The author's plans chest at Artichoke, London.

Conclusion

I AM MORE OPTIMISTIC NOW, concerning the 'health' of printmaking, than I was five years ago. Printmaking has been under attack at grass-roots level due to cuts in art-school printmaking departments. There has been an ongoing battle waged by a few dedicated printmaking academics across many institutions to fight off non-artistic middle management intent only on grabbing floor space to boost student numbers – you could call it 'bums on seats finance'. It still saddens me, for example, that a student attending a major art school may not have access to an etching press on campus.

However, cuts in printmaking within art schools, seem to have bottomed out, and I am even encouraged by news of new printmaking courses starting up.

Independently, printmaking is as well served as ever with some excellent open-access studios, both funded and private, being available throughout the UK. Paper and materials suppliers are positive and plenty of printing presses are being built. Moreover, new materials and techniques are being added to the printmaking repertoire; safer, non-toxic techniques, of which those that work well have been adopted and are used alongside the tried and tested traditional methods. At one point it seemed to me that the push for green methods would throw the baby out with the bath water? 'Safer' techniques must be practical and they must be capable of matching standards and practice at the highest professional level if printmaking is not to be dumbed down. Happily, it seems this kind of common-sense assessment has prevailed.

For me, one of the most important aspects of printmaking is the education and encouragement of the next generation, who are, after all, the future printmakers and patrons of the arts. I always take the opportunity to work with schools and to give practical, hands-on demonstrations at art fairs and events. Educational work reinforces printmaking – the making of original works, as opposed to the reprographic copying of a work that exists in another medium. There is nothing quite like experiencing at first hand the magic of seeing a print pulled for the first time.

Wilf, George and Stanley enjoying a half-term class in etching. Artichoke, 2007.

Wilf George Stanley

Suppliers

Antique Machinery Removal (AMR)
Tel: 0044 (0)1539 736111
www.amremoval.co.uk
Press engineers and movers.

Art Equipment
3 Craven Street
Northampton
NN1 3EZ
Tel: 0044 (0)1604 632447
Hotplates, etching presses, aquatint boxes, tailor-made acid trays, sinks and fume cupboards.

Artichoke Print Workshop
Unit S1, Bizspace
245a Coldharbour Lane
London
SW9 8RR
Tel: 0044 (0)20 7924 0600
www.artichokeprintmaking.com
Suppliers of etching blankets and the KB etching press.
Also editioning services and an open-access workshop.

Cornelissen
105 Great Russell Street
London
WC1V 3RY
Tel: 0044 (0)20 7636 1045
www.cornelissen.com
Tools, inks, quality pigments and copperplate oils.

Daler Rowney
PO Box 10
Bracknell
Berkshire
RG12 8ST
Tel: 0044 (0)1344 461000
www.daler-rowney.com
Screen-printing, system-base and acrylic paints.

Harry Rochat Ltd
15a Moxon Street
Barnet
Hertfordshire
EN5 5TS
Tel: 0044 (0)20 8449 0023
www.harryrochat.com
Press engineer and manufacturer.

Intaglio Printmaker
62 Southwark Bridge Road
London
SE1 0AS
Tel: 0044 (0)20 7928 2633
www.intaglioprintmaker.com
General printmaking suppliers for inks, rollers, sundries, etc.

John Purcell Paper
15 Rumsey Road
London
SW9 0TR
Tel: 0044 (0)20 7737 5199
www.johnpurcell.net
Fine art paper merchant.

Mati Basis
13 Cranbourne Road
London
N10 2BT
Tel: 0044 (0)20 8444 7833
Steel-facing copperplates.

Richards of Hull
Unit 1
Acorn Estate
Bontoft Avenue
Hull
HU5 4HF
Tel: 0044 (0)1482 442422
www.richards.co.uk
Tailor-made acid baths, sinks,
ventilation and extraction units.

R.K. Burt & Co
57 Union Street
London
SE1 0AS
Tel: 0044 (0)20 7407 6474
www.rkburt.co.uk
Fine art paper merchant.

Rollaco Engineering
72 Thornfield Road
Middlesborough
Cleveland
TS5 5BY
Tel: 0044 (0)1642 813785
www.rollaco.co.uk
Press manufacturers. Suppliers of
rollers, tools and inks.

Sericol
Tel:0044 (0)1992 782619
www.sericol.co.uk
Everything for screen-printing.

Smiths
London Metal Centre
42–56 Tottenham Road
London
N1 4BZ
Tel: 0044 (0)20 7241 2430
Copper sheet.

Sun Chemicals
Bradfield Road
London
E16 2AX
Tel: 0044 (0)20 74739400
www.sunchemicals.com
Printing inks for screen-printing
and lithography.

T.N. Lawrence
Mail order and Hove shop
208 Portland Road
Hove
Sussex
BN3 5QT
Tel: 0044 (0)1273 260260
www.lawrence.co.uk
General printmaking suppliers for
inks, rollers, sundries, etc.

W. & S. Allely Ltd
PO Box 58
Alma Street
Smethwick
West Midlands
B66 2RP
Tel: 0044 (0)121 558 3301
Copper and aluminium sheet.

Glossary

Acid a strong corrosive liquid used in the etching process. Typically, ferric chloride, nitric or copper sulphate. Also acetic acid used in lithography.

Acetate clear thin mylar or plastic used for making stencils, or for registration, or as a surface for outputting inkjet images from a printer.

Albion press A cast iron Victorian press used for relief printing.

A la poupée a method of inking a plate with more than one colour of ink. The colours are inked and scrimmed individually onto the plate one at a time. They can be deliberately blended to create mixed colour areas.

Ammonia household cleaner mixed with water and chalk for degreasing metal plates.

Aquatint An etching technique in which a resin dust is added to the plate by heating it onto the surface of the plate. The acid only bites the plate in the areas between the dust particles thus creating a tonal value on the plate. Originally developed to produce water colour type effects.

Baren a japanese tool usually large circular or oval shaped and covered in bamboo used for hand burnishing.

Bench hook a wooden support to hold a block safely whilst cutting with a tool.

Bevel the angle that is filed onto the edge of an intaglio plate before printing it. The angle is usually 45 degrees.

Block printing surface referred to in relief print such as the lino block or wood block.

Blue Etch Resist An emulsion that is applied with a roller and used for photo etching.

Burin A tool used for engraving.

Burnisher a smooth curved tip tool used on metal plates to polish an area that has been removed by a scraper. A burnisher can be used to lighten and area that is too dark.

Burr the wisps of metal that a drypoint needle pulls up when it is drawn through and into the surface of a metal plate. These edges of torn metal hold the etching ink and create a dramatic line.

Carborundum Aluminium Oxide particles used to regrain stones in stone lithography. Also used with an adhesive such as pva, to create texture on collagraph plates. Commonly referred to as 'Grit', it comes in different grades: usually fine, medium and coarse.

Coating trough An aluminium container used for coating screen mesh with light sensitive emulsion.

Collagraph a print made from a block or matrix on which collaged materials with texture have been glued.

Columbian Press A cast iron Victorian press for relief printing, characterised by an eagle shaped counter balance.

Copper a metal used for intaglio processes. It is available with a polished surface. It lends itself well to clean even width lines due to the way the ferric acid bites into the surface.

Copper plate oil Boiled linseed oil used for modifying ink consistency or for mixing with dry pigment to make ink. Supplied in thick, medium and thin.

Diffusion dither a Photoshop application, that renders an image in fine random dots.

Drafting film a semi transparent textured drawing film.

Drypoint the technique where only a needle with a sharp tip or roulettes are used to make marks

in the surface of a metal plate. No acids are used when making a drypoint.

Drypoint needle A metal tool with a sharp tip used to make marks in the surface of metal.

DPI dots per inch. The resolution of a digital image which is crucial to the quality of the image when it is outputted.

Emboss a raised design created when damp paper is pressed onto the surface of a matrix that is passed through a printing press. Blind emboss when no ink is used.

Engrave an incised mark made with specific tools on a block such as copper or fine grained wood. No acid is used.

Etching intaglio process in which an image is created on a metal plate using acid. A technical term in lithography, for the chemical separation of the greasy and non-greasy areas.

Etching blankets Felted and tightly woven wool cloth that is cut to size to fit the bed of a printing press. They help push the dampened printing paper into the grooves and lines of the etching plate.

Ferric chloride An Alkaline solution for biting copper etching plates. It can also be used for zinc and aluminium if mixed with water to the correct ratio. It has no fumes.

Gesso a mix of plaster of paris and glue used to create texture on a collagraph matrix.

Flexograph photopolymer intaglio process. Also called 'Solar Plate'.

Ground grounds can be hard, soft or liquid. They are used to protect the surface of etching plates and to cover the surface of a plate so that an image can be drawn or impressed into them.

Gum arabic a natural material sourced from the acacia tree used in lithography for processing the image on a plate or stone.

Gum strip adhesive brown tape, useful for taping down large intaglio prints to dry them quickly.

Half tone screen a photographically produced screen with a random dot structure, that mimics the effect of aquatint grain.

Hand burnish printing without a press with a baren or wooden spoon using the pressure of your hand.

Hard ground a wax resist for traditional etching.

Hotplate a metal surface with a heating element underneath. Used for laying hard and soft grounds on plates for etching.

Intaglio printing processes which involve inking marks that are cut or incised below the surface.

Lino/linocut a matrix on which the image made is cut into a linoleum tile block.

Matrix the chosen plate or surface on which the printmaker chooses to make the print. Can be card, plastic, metal or wood.

MDF medium density fibre board. A manufactured composite wood-base. Similar to chip board, except with a much finer smoother grain. It is available in different thicknesses.

Metal plates of zinc, copper, steel, or aluminium.

Methylated spirits denatured alcohol. A solvent used for aquatint resin removal. Also to remove straw hat varnish/shellac, and permanent marker pen.

Monoprint a unique one-off print made by printing on an unmarked surface of metal, acetate or thin perspex.

Mould made paper [using the same quality ingredients as hand made paper] that is formed using a mesh like mould. The most commonly used paper for printmaking.

Nipping press a hand press designed for bookbinding, it can be used for printing relief blocks.

Nitric acid HNO_3 mixed with water to etch copper, zinc and steel. It is also used in lithographic etches.

Nap roller a leather roller used for non-drying roll-up black in lithography.

Painter a computer software package which mimics traditional drawing and painting materials.

Photo opaque an opaque liquid used to paint out negatives in photography. It can be used as sugar lift. It is also used for drawing opaque images on semi-transparent drafting film.

Photoshop computer software package used for image manipulation.

Photolithography light sensitive aluminium plates used for printing lithographs.

Planographic printing from a flat surface as in lithography.

Plate general term for the matrix in a printmaking process.

Plate tone tonal surface effect achieved when inking and printing an intaglio plate.

Polymer plate a plate which has a light sensitive polymer emulsion, or light sensitive film coating on its surface which can be exposed to UV light or sunlight using positive artwork.

Positive artwork for making photo plates and photo screens. Opaque marks, usually on clear acetate made by hand or outputted from a computer printer.

P.V.A. glue a water-based glue useful for making collagraph plates.

Registration the means by which the paper and printing block are accurately aligned for the precise fitting of all shapes and colours in the image.

Relief Print made by taking an impression from a matrix in which only the upper surface of the matrix has been inked.

Roulette A tool with a spinning wheel tip which is textured with fine lines or dots.

Scrim cotton mesh cloth used for wiping intaglio plates, also called tarlatan.

Smoking The procedure of darkening a hard ground plate, using a bunch of wax lighting tapers.

Snake stone A granite type stone [water of Ayr stone] for polishing the surface of a lithographic stone.

Soft ground A technique using a soft wax to create pencil type lines and or textures on an etching plate.

Sodium carbonate A mild detergent used for developing various photoetching plates.

Somerset A mould made English printmaking paper.

Straw hat varnish Methylated spirits based varnish for sealing the surfaces of card or wood. It is also used as a coating in lift gounds/sugarlifts and as a protective coating on metal plates in the etching process.

Steel a metal used for intaglio processes. It is coarse metal and has a heavy surface tone which makes it ideal for colour etching.

Stencil Stencils are designs cut from paper, acetate or thin card and applied to a plate, block or screen. Ink is then applied through the open areas of the design. The uncut areas of the stencil act as a suitable barrier or mask.

Stone lithography The original lithographic technique using Bavarian limestone.

Stop out varnish white spirit based varnish painted on to metal, to resist the action of acid.

Transfer paper A gum coated paper for drawing on, prior to transfer onto a lithographic plate or stone.

True Grain A high quality semi-transparent drafting film.

Tusche A greasy drawing material used in lithography. Supplied as a liquid or in a solid block to be dissolved.

U.V. exposure unit A unit for exposing plates and screens to ultraviolet light.

Whiting Chalk-calcium carbonate in powder form used to degrease intaglio plates.

White spirit A solvent which is used for cleaning ink from plates and removing grounds and stop out varnish.

Woodcut a print made from wood that has been cut as plank length. Example: plywood or composite board such as mdf or hardboard.

Wood engraving a print made from the end grain or cross grain of a hardwood such as apple, pear or boxwood.

Zinc a metal used for intaglio processes.

Index